Two Knotty Boys

Showing You the Ropes

Two Knotty Boys
Showing You the Ropes

A Step-by-Step, Illustrated Guide for Tying Sensual and Decorative Rope Bondage

Dan and JD, the Two Knotty Boys

Photographs by Larry Utley

Green Candy Press

Two Knotty Boys Showing You the Ropes
by Dan and JD, the Two Knotty Boys
www.knottyboys.com
ISBN 10: 1-931160-49-X
ISBN 13: 978-1-931160-49-0
Published by Green Candy Press
www.greencandypress.com

Cover and interior design: Ian Phillips
Cover image: Larry Utley
Cover model: Anyssa

Printed in the USA.
Massively distributed by P.G.W.

Contents

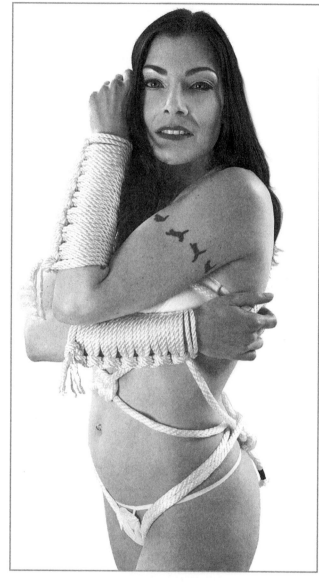

Foreword

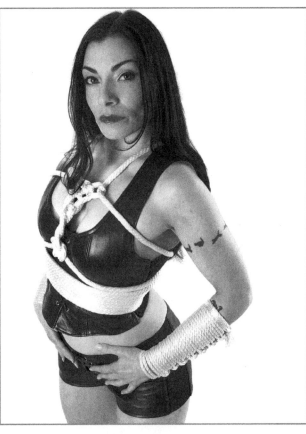

Rope bondage was my first love in BDSM, and it remains my best love to this day. I have always enjoyed the consensual erotic helplessness it creates, along with its grace and beauty. I have studied its various forms intensely, and it has been my humble privilege to have some of my own writings and workshop teachings added into its body of knowledge.

For the better part of a decade, Dan and JD—the Two Knotty Boys—have been making major and positive contributions to the world of pleasurable, safe and erotic bondage. They have an excellent reputation, and rightly so. I have had the distinct pleasure of attending their workshops and observing how they teach with exceptional skill, knowledge and humor. And even this old dog has learned a few new tricks from them. Their many presentations, both in person and on video, have done a lot to popularize this exciting form of erotic play. The Two Knotty Boys are educated and professional in their approach, and instruct with exceptional style. Plus, on a personal level, they are just plain and simply wonderful fellows to know. I always enjoy "talking rope" with them.

With this volume, the Two Knotty Boys make an invaluable contribution to the body of knowledge surrounding the art of erotic, safe, and consensual rope bondage. Carefully thought out by JD and Dan and both lovingly and skillfully photographed by Larry Utley, this book guides the reader

from the most basic aspects of rope bondage into some of its more advanced techniques. Starting, quite properly, with a discussion of safety matters and basic information about rope, the Two Knotty Boys go on to carefully introduce the reader to basic knots, and then guide the reader on to simple techniques before easing into the more advanced practices. All of this is done with care, attention to detail, warmth, humor and—reader take warning—the occasional dreadful pun.

Dozens of techniques are demonstrated. Want to learn simple ways to tie your lover's wrists and ankles? Those are explained here. How about a more complex body harness or arm binder? Take your pick of the several herein. Gags? They've got them. Want to tie your sweetie to a chair, table or bed? A number of approaches are laid out like a smorgasbord for your choosing. How about articles of rope bondage clothing such as panties, corsets, bras or gauntlets? They're here too. There is even a most ingenious technique shown for using rope to create a strap-on harness.

Overall, this is a solid, very usable introduction to the basics, and more, of erotic rope bondage. I unhesitatingly recommend this book to anyone interested, be he or she raw beginner or advanced practitioner.

Jay Wiseman, Author of *SM 101* and *Jay Wiseman's Erotic Bondage Handbook*.

Acknowledgments

For cooperation with and/or inspiration in the production of this book, Two Knotty Boys would like to thank Larry Utley, Caroline Harrington, Damion Kelley (Castlebar), Andrew McBeth (Green Candy Press), Cleo Dubois, Randy Imler, George Lazaneo (Bondage-A-Go-Go), Paul Nathan, Peter Acworth, Margaret (AKA KitNboots), Jay Wiseman, Kristen Kakos, Robert G. Pimm (California Lawyers for the Arts), Margaret Wolfe, Mistress Pandora, Juliette Tai, Sarah Fishman, Lou Duff, Clifford Ashley (Book of Knots) and everyone who has ever attended, hosted or modeled for a Two Knotty Boys workshop. We learned something from all of you.

Introduction

There are thousands of great books about knots. There are also many great books about bondage. However, as we complained when first trying to learn rope bondage ourselves, there are very few books that clearly illustrate the step-by-step process of turning great knots into great bondage. It's one thing to know how to tie an Eagle Scout's worth of sheep shanks, bowlines and clove hitches. It's another thing to know how to tie a former Eagle Scout... or a former Girl Scout... or just someone who dresses like one at night.

Putting knots to work on the human form is an entirely different skill from the sort of knot techniques involved in seamanship, mountaineering or basket weaving—especially if you want your bondage to be safe, sensual, attractive and effective. Like we always say in our in-person, hands-on rope bondage workshops: you're not tying rope; you're tying people.

When we began teaching rope bondage together in 1999, we discovered that most people learn best when they're shown—close-up, step-by-step, and repeatedly—how to tie basic knots and combine them

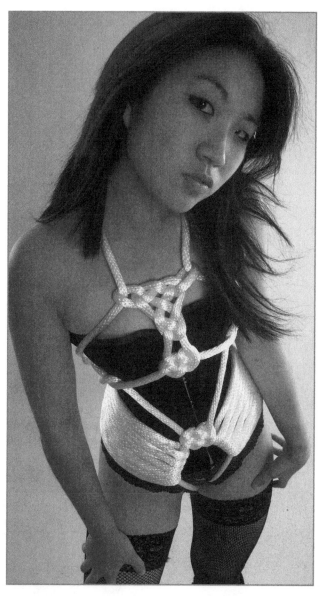

into bondage techniques. That's the learning process we duplicate in this book. With the help of our photographer and dear friend Larry Utley, we use photos and captions to show—not tell—the soup-to-nuts techniques for turning rope into rope bondage. Forget long texts. Forget dissertations about BDSM or how to be a Dominant. There are plenty of books that cover that thoroughly. Our book fills a gap between books about knots and books about bondage.

Unlike videos or DVDs that you have to play and memorize, this book serves as a bedside companion to actual bondage. With easy-to-understand captions and clear step-by-step photos, you can learn at your own pace, review whole techniques at a single glance, and even lay the book flat on the table (beside your blindfolded partner) and follow along as you tie like a lifelong Dom/Domme.

This is the book we wished we had when we first got curious about rope bondage. This book will let you avoid many mistakes and frustrations so you can skip right to the action.

Rope Bondage Safety

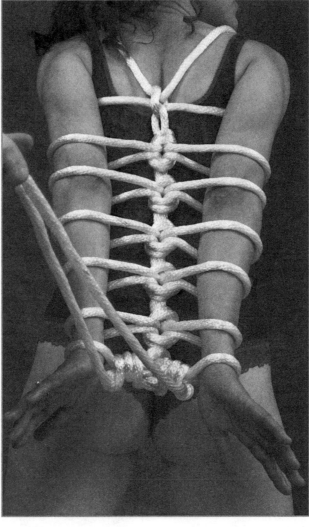

Again, the difference between tying bondage and tying knots is that with bondage, you're not just tying rope; you're tying *people*—people with bodies, circulatory systems, nerves and emotions (like *vengeance*, for example). For this reason, safety must be your first concern when tying any of the bondage pieces outlined within this book, without exception.

Damage to the nerves and blood supply are the primary safety concerns related to rope bondage. Disruption of blood circulation in any part of the body, regardless of whether it occurs in a region of a major artery or an isolated capillary network, can lead to (undesirable) pain and, eventually, tissue damage. Examples of tissue damage include bruising, temporary or permanent nerve damage and in extreme, unmitigated, situations necrosis (tissue death).

Symptoms of circulation interruption include numbness, a tingling sensation, pain, a drop in skin temperature and a skin color change to pale white or blue. Circulation disruption is not the only threat to nerves. Sudden pressure, such as an impact or jerking on a rope, can also cause harm, even instantly.

If the person you are tying experiences pain or any of the symptoms listed above, remove the rope immediately!

Great care must be taken to prevent such damage. This also requires communication on the part of the person being tied, to inform the person tying him or her of any symptoms of oncoming circulation loss. Damage can happen surprisingly quickly. The person tying must also pay extra attention to checking in and monitoring the physical state of the person being tied (or *persons*, if you're lucky).

The bondage techniques described in this book are designed to be effective without being particularly tight. Also be aware of the physical limitations of the individuals you are tying. Not everyone has the range of motion or the (perhaps freakish) joint flexibility of the models pictured in this book, so you'll have to make adjustments accordingly to suit the comfort of your partner. Again, communication is key.

Rope Bondage Dos and Don'ts
Thankfully, the dangers associated with rope bondage don't have to occur; all are preventable with good techniques and sensible precautions. Here are some commonsense Dos and Don'ts that will help ensure safety during your rope bondage experience.

Bondage Safety—Things to Do

• *Do make restraints "two fingers loose,"* or loose enough that you are able to work one or two fingers between the rope and the body.

• *Do monitor circulation every ten minutes.* Every ten minutes or so, check for unusual cooling of the skin or discoloration (usually whitening) on the limb past where the rope is tied. Ask your partner if any extremity is going numb or if any binding is too painful.

• *Do insist your partner notify you* of symptoms of circulation loss immediately, such as numbness, tingling, "pins and needles" sensation or undesirable, distracting pain.

• *Do multiply the points of tension* to spread the effect over a wider area. Don't limit a tie-down to a bed, for instance, to attachments at the wrists and ankles; attach ties to the elbows, knees, shoulders, waist and thighs as well. The more widely distributed the tension of tie is, the more exciting and safe that tie will be.

• *Do make sure you know how to undo your ties* before you put them on your partner. Be prepared to cut difficult knots or bonds in an emergency. To do this, keep safety scissors (also known as EMT shears or bandage scissors) handy at all times. They're available at most well-stocked pharmacies.

• *Do go slow with novices* and during first encounters. Be especially sensitive to your partner's emotional reactions, providing frequent gentle body contact, spoken encouragement and reassurances. Watch out for developing panic. Also understand the critical importance of gaining your partner's consent before any level of progressing physical contact.

• *Do remove restraints gently,* being careful not to cause rope burns. Lower the arms and legs so blood can flow in. Massage any area that has become numb; if necessary, apply warmth to restore circulation.

Bondage Safety—Things NOT to Do

• *Don't make any tie too tight,* especially around joints (wrists, elbows, knees, ankles) or the neck—anywhere that major arteries or veins are near the surface.

• *Don't leave someone who's inescapably tied alone.* Circulation problems can get very bad, very quickly—not to mention what might happen if other medical emergencies occur or if the people you tie struggle to the point of falling and injuring themselves. Other emergencies, such as fire, earthquake or "Honey, I'm home," could also prove disastrous if they were left alone with no way to free themselves.

• *Don't gag your partner* unless you provide an alternative method for him or her to communicate problems with circulation or other emergencies.

• *Don't attempt a rope suspension without proper training,* and never bind persons where support of their weight relies on a fixture, bolt or construction that has not been designed to bear a load many times their weight.

Properly monitored with open communication, rope bondage can be safely practiced by almost anyone. Keen and constant awareness of your partner's physical and emotional state is more than the key to safety—it's also the key to sensuality.

A Few Lines About Rope

People who come to our bondage workshops usually have as many questions about rope as they do about knots. It's not surprising, since there's such a wide and confusing variety of cordage available. So—to borrow a phrase with its own sadistic origins—here are a few simple rules of thumb.

The Right Rope

What's the best rope to use? The answer boils down to a matter of personal taste (especially if you're using your rope to make bits or rope gags). Since there are too many specific types to discuss here, let's stick with the three types of rope most commonly preferred for bondage: nylon, cotton and hemp (or jute). Each has its own qualities that appeal to very different styles of BDSM, and each has its pros and cons.

Nylon

Nylon makes awesome general-purpose bondage rope. We recommend solid braid cording. It has a beautifully smooth appearance and feel. We also like it because it holds its shape

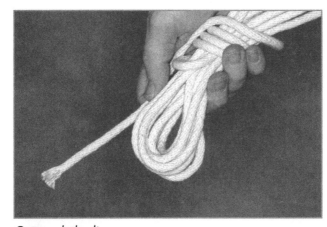

Cotton clothesline.

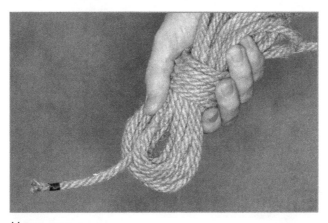

Hemp rope.

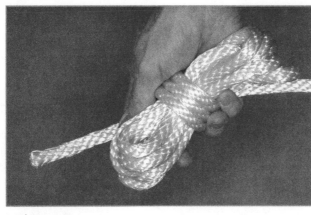

Nylon rope.

under any twisting force—unlike twisted braid which deforms slightly when braided or tied into complex woven knots.

Buying solid braid also eliminates the chore of having to pull the core out of your rope before using it. Ropes with cores are bulkier and harder to tie into secure knots, so most bondage players remove the core, turning a $3/8''$ diameter line into one hollow $1/4''$ tube (plus one free cat toy). Whether solid, twisted or cored, nylon offers these nice characteristics:

- Soft, silky-smooth texture is most comfortable (though easily causes rope burn).
- Ideal for sensual scenes and people new to rope bondage.
- Extremely strong and durable.
- Knots remain easy to untie, even after strain.
- Reasonably priced and easily available at hardware stores or online.
- Flame-meltable fiber makes ends easy to secure to prevent unraveling.
- Ready for use, easy to maintain and machine washable.

Cotton

Okay, so maybe there weren't as many rope choices out there in the '50s. If there had been, I think Bettie Page might not have made quarter-inch cotton clothesline the popular thing that it is today. Then again, it is hella cheap and available at many all-night grocery stores. "Hmm… cigarettes (beep), condoms (beep), and fifty feet of rope (beep). Big evening planned, eh?" Though it looks somewhat amateur, cotton does have its own unique appeal.

- Rough and stiff right out of the package, for more intense scenes.
- Softens up in the wash for more sensual play.
- Holds knots very tightly, especially when wet.
- Gives that vintage look to any scene.
- Bites into the skin, due to narrow gauge and nonslip texture.
- Frays and breaks very easily.
- So cheap and easily available it's disposable.
- You can cut it to pieces without remorse.
- Holds dye perfectly, so it's the easiest to color.

Hemp (Jute)

Jute is the traditional rope used in Japanese bondage, though hemp is a very good and more easily-obtainable substitute. This brown, twisted-braid, natural-fiber rope is available "raw" or "finished." With a finished feel and aroma similar to burlap or a virgin wool sweater, it's the perfect rope for Japanese-style suspension or restraining your prisoners in the *hojo jutsu style*.

Naturally stiff, splintery and very rough, the raw rope requires extensive preparation before it is suitable for erotic bondage. This process involves whipping (winding the ends with thread), boiling, hang-drying away from sunlight, "sanding" repeatedly with a canvas cloth, burning off loose fibers, lightly oiling and many other steps. (The complete process can be found at https://rope365.com/rope-care/, or in Fetish Diva Midori's book *The Sensual Art of Japanese Rope Bondage*.) The required craftsmanship is well worth the effort. You get rope with these qualities:

- Authentic Japanese effect, with organic color, feel and scent.
- Highly abrasive texture discourages people from struggling.
- Knots stay very tight, especially under strain.
- Ideal for intense bondage scenes demanding motionless submission.
- Traditionally cut into 25' sections.
- Susceptible to breaking; easily frayed by abrasion and wear; easily cut.
- Difficult to find (especially pure jute) and most expensive.
- Requires considerable preparation, maintenance and careful storage.
- Not suitable for frequent washing.

Size Matters

The larger a rope's diameter, the less pressure it puts on the flesh. For most limb-bondage applications, $3/8$" – $7/16$" diameter is just right. If you use smaller rope, such as $1/4$" jute for Japanese bondage or cotton clothesline, it's best to wrap or repeatedly "band" the ropes around the body/limb to spread the pressure across a larger area. You'll also need to more closely monitor your partner to avoid injury to veins or nerves.

Quarter-inch rope is also excellent for some decorative knot work, such as arm gauntlets or bondage of the hair and face. Rope (or twine) less than $1/4$" is best reserved for intricate work such as finger, toe or nipple bondage. Rope that's $1/2$" or greater is suitable for suspension and heavy muscular bondage. However, its size makes knots so bulky that they loosen easily, appear sloppy and feel uncomfortable.

How Long Have You Got?

The length of rope you will need varies greatly with the design you intend to tie, the diameter of your rope, and the size of your model. As an example, a good rope corset of about seven doubled winds around the torso requires about 40' of $^3/_8$" rope. To cover the same area with a finer, more delicate rope ($^3/_{16}$") requires about 100' (not recommended, unless you are patient enough to repeatedly untangle it).

It's useful to have a variety of lengths. Shorter lengths of 6'–10' are good for single-limb restraint. 30'–40' is a great standard for most decorative, harness and double-limb wrapping. 25' sections are de rigueur for Japanese-style bondage. Body harnesses are rope hogs, so allow 50'–60'. Plan a little longer than you think you will need. You can always cut or braid the excess. You never curse the two inches you have, only the two inches you don't have!

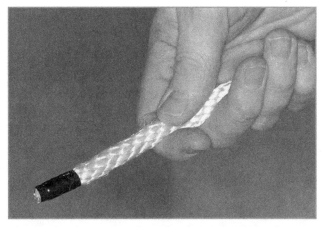

Electrical tape is a quick and easy way to keep the ends from fraying. Tightly wind the tape where you want the ends; then cut in the middle of the taped portion to render two finished tips.

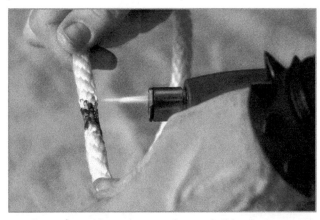

Synthetic rope like nylon can be sealed by melting with a flame. (A chef's torch works best.) First, lightly melt an area about an inch wide. Let it cool. Then cut it in the middle with scissors.

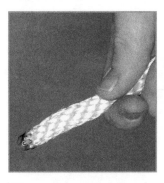

After you've cut the premelted rope, heat the ends again and taper the tips to prevent them from snagging your rope.

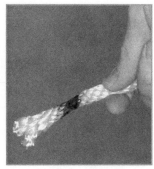

For softer tips, you can trim the end a couple of inches away from the melted section and fray the end into a tassel.

At the End of Your Rope

All rope ends can be finished using a simple knot, or wrapped with cloth/electrical tape, or sealed with latex "tool dip," or just left to fray into tassels. A popular finishing is whipping—especially for natural fiber ropes like hemp and jute. Whipping requires a careful technique (easily found in books or online) to wind thread around the ends. The drawback of whipping or tool dip is that repeatedly pulling the ends through knots can unravel the whipping or wear off the seal.

The ends of nylon or other synthetic rope can be melted with a flame. For melting, we recommend pinching the hot ends down so that the sharp, hard "mushroom scab" doesn't scratch skin or fray the rope each time it's pulled through a knot. You can make such "bullet ends" more easily if you first lightly melt a small area across the spot you're going to cut. Then melt the cut ends and shape the hot tips using thick gloves or other padding.

Another neat tip-finisher is clear or colored nail polish. Paint an inch across where you want to cut, saturating the rope. Let it dry overnight. Then cut in the middle of the painted section and apply a finishing coat to the ends. Alternatively, you can cut an inch or so away from the painted section and fray the end for a soft tassel that won't unravel past the nail polish.

Care and Feeding

Don't be gross. Wash your rope if visibly (or aromatically) soiled—especially after hot sweaty scenes or if your play involved bodily fluids or lube (we could only hope). The best way to wash most rope is to chain braid it (see Chain Braiding) and slip it into a lingerie washing bag or a closed pillowcase. Wash it on delicate cycle. Do not use liquid detergents, liquid bleach or fabric softeners, which will leave an oily feel to your rope. (Same goes for dryer sheets.) For best results, hang the rope up to air

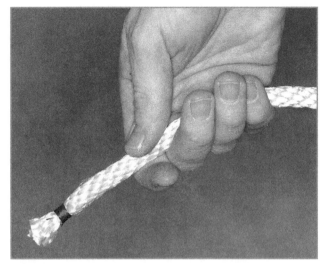

Whipping—winding several feet of thread around the end—is a good way to secure the tips of natural fiber rope, like hemp, which doesn't melt.

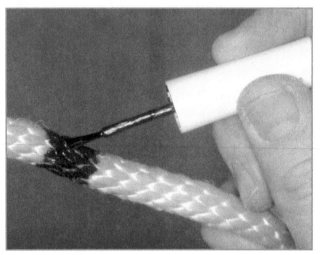

Nail polish (clear or colored) can seal the rope too. Allow to dry and then cut in the middle of the painted section.

Once cut, apply a coat of nail polish to the exposed ends and let dry.

Alternatively, cut the rope a short distance from the painted section to create soft tassels. The rope won't fray beyond the seal.

dry, after first unbraiding it so it doesn't develop an unsightly "memory."

Hemp rope should only be washed infrequently, as water weakens it. Keep it away from sunlight. You may also want to rub it using a mink-oiled piece of canvas once a year to maintain its suppleness.

If you like to add color to your rope, you can easily dye many types of rope using liquid Rit® dye in a large (2–3 gallon) pot on your stove. (Follow the directions on the package). Cotton dyes easily. Even most solid braid nylon holds dye if its weave is loose enough, but consider it an experiment. Hemp dyes well too, but that's almost sacrilege. If you must have colored rope and don't want the fuss, www.twistedmonk.com is a good online source.

In the End

Like your style of bondage, the rope you use is a personal choice. Plus, it's fun to experiment.

The Knots

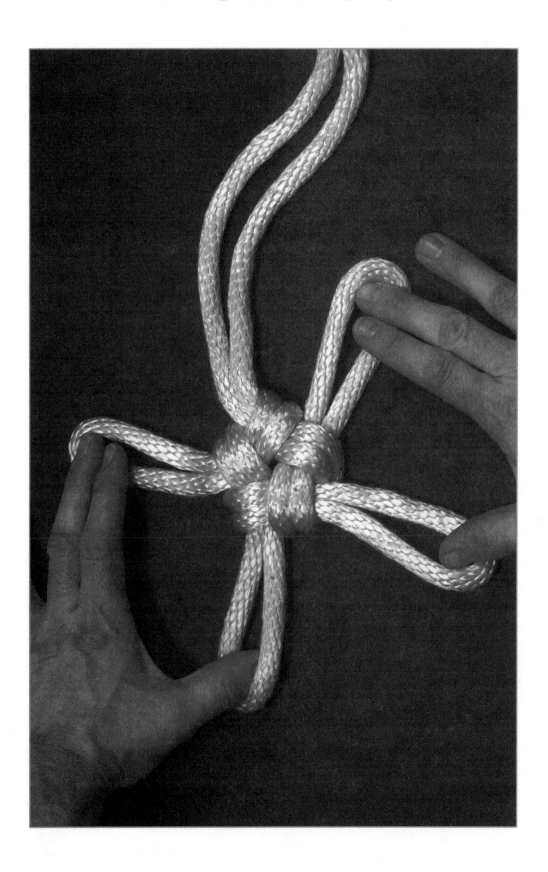

Square Knot

This essential knot is one of the most frequent you will tie. It's quick. It's easy to tighten for holding pieces securely. It's also a flat knot that is comfortable against the skin. The drawbacks of this knot are that it can loosen when the ends are pulled, and it's also easy to mis-tie into a granny knot, which looks similar but the ends come out perpendicular to the knot instead of parallel to each other, so it doesn't lay flat.

Rope length: Any length
Rope diameter: Any diameter

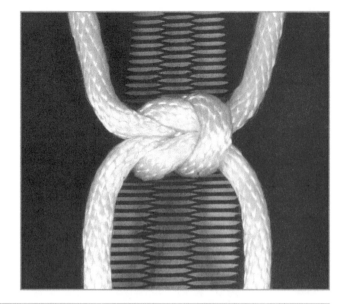

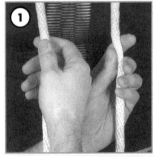

1 With two ropes hanging down, take the right rope in your left hand and the left rope in your right.

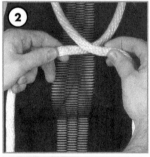

2 Cross the left rope over the right rope...

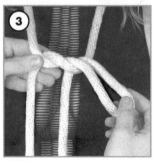

3 and wrap it under the right rope. Then pull the end all the way over the top.

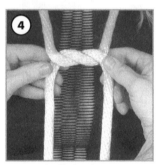

4 (You're halfway there!) Again you have two ropes hanging down.

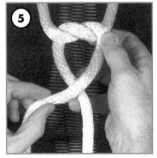

5 Now cross the RIGHT rope over the left rope.

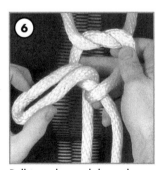

6 Pull it under and through.

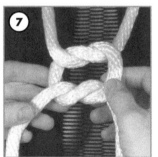

7 Now tighten the knot by pulling the ends. A common mantra for tying the square knot is: "Left over right and under; right over left and under."

DONE You know you've tied it correctly if both ropes on each side of the knot come out together or parallel. If you've mis-tied it, simply back up halfway and wrap the ends opposite the way you did.

Bow Tie Knot

Here's a quick and easy way to tie a pair of wrists together for a quick "handcuff" technique. It's ideal for suddenly restraining your partner's hands while you lead him or her across the room. It's also the initial knot that's used over the shoulders when tying the Dragonfly Sleeve. Only things to beware of: these are both slipknots,so it's easy to cut off circulation. Plus, they can loosen easily unless you finish them with an overhand knot.

Rope length: Any length, from 10 to 100 feet
Rope diameter: ¹/₄ inch to ¹/₂ inch

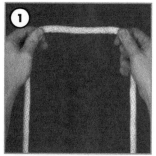

1 Start with your right hand in the very middle of the rope, and your other hand holding on about 6 inches left of center.

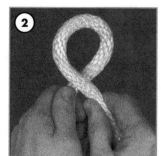

2 Curl the rope RIGHT OVER LEFT to make a small loop.

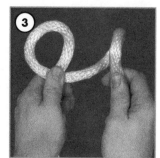

3 Pinching the loop together with your left thumb, make another loop, again right over left.

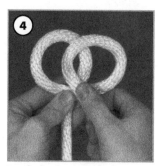

4 Pinch the loops together and merge the right loop halfway over the left loop to form a Venn diagram or a MasterCard® logo.

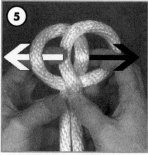

5 Pull the right half of the left loop through the FRONT of the right loop while pulling the left half of the right loop BACK through the left loop.

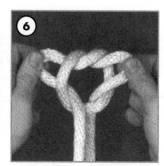

6 Pull out the "ears" of these loops while tightening the knot at the center. It's just like tying your shoelaces, only without shoes, natch.

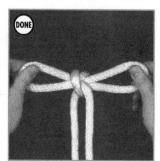

DONE Open the loops so that they are large enough to fit onto the wrists of your partner. Holding the center knot, pull the ends of the ropes to tighten booth loops over the wrists.

Double Slipknot

Generally speaking, Double Slipknots are an unwise choice for bondage, on account of their tendency to tighten as strain is put on them. However, if tied in conjunction to a well-structured piece like the Dragonfly Sleeve or properly hitched off when used as a wrist tie, the Double Slipknot makes a quick, useful technique.

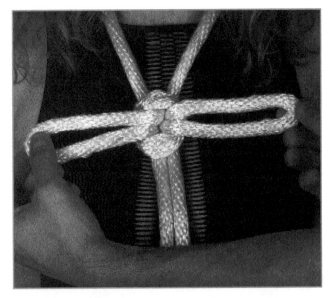

Rope length: Dependent on piece being tied

Rope diameter: ³/₈ inch to ⁷/₁₆ inch

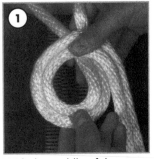

With the middle of the rope around the back of your partner's neck, gather the two ends of the rope into a pair. Then rotate them clockwise over themselves into a flat circle.

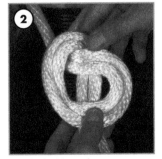

While holding the point where the ropes cross securely between your thumb and forefinger, fish the ropes behind the loop they created.

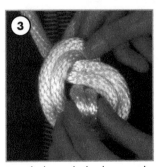

Reach through the loop with your thumb and forefinger and pinch the two ropes that hang behind…

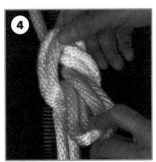

and carefully pull them out toward you.

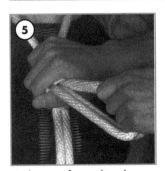

With one of your hands, grip the loop at the base of the protruding double loop, and with your other hand grip the bight of the double loop. Pull the bight of the double loop…

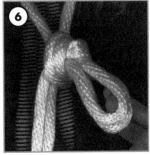

so as to create a tight loop around the base of the protruding double loop.

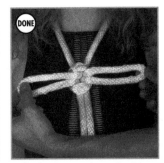

Split the protruding double loops, and, lo and behold, a Double Slipknot!

Fisherman's Knot

Also known as the Water Knot and the Angler's Knot, the Fisherman's Knot's primary use is fitting one length of equal diameter rope (or fishing line) to another. The knot can also be used to make a surprisingly secure—yet safely disengaged—loop for the breast, nipples and male genitals!

Rope length: Depends on "piece" being tied
Rope diameter: 1/4 inch to 7/16 inch

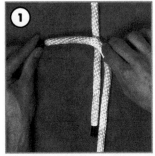

1 Begin by laying separate ropes parallel to one another. Cross the rope on the right-hand side over...

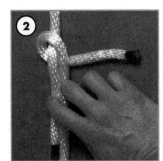

2 and then under the rope on the left-hand side, under itself...

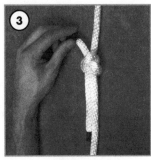

3 and through the loop that you created.

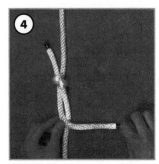

4 Now, cross the rope on the left-hand side over...

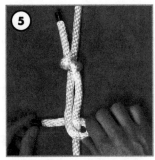

5 and then under the rope on the right-hand side, under itself...

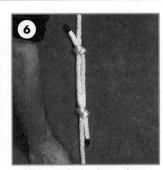

6 and through the loop that was created—just as before.

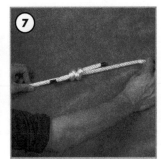

7 To tighten the Fisherman's Knot, pull on the long ends of the two ropes.

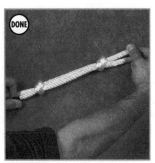

DONE To loosen the knot, pull on the short ends.

Double Coin Knot

Here is our favorite knot! This Asian knot symbolizing prosperity has been used as a decorative knot for thousands of years. We like it because it presents potential loops on each corner where ropes can pass through, making it ideal as a central knot for an unlimited variety of rope harnesses. It's also a flat knot that is comfortable to wear and lie upon. Plus it makes anyone look like a rope Master.

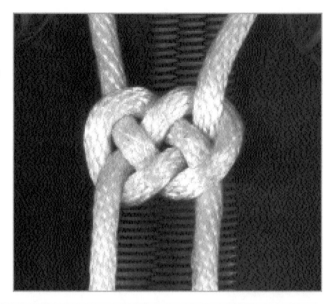

Rope length: Any length, from 1 to 100 feet
Rope diameter: 1/4 inch to 1/2 inch

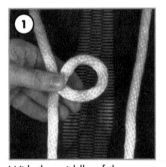

With the middle of the rope hanging around your partner's neck, make a counter-clockwise P shape with the left rope. Make sure the bottom of the P is behind the top.

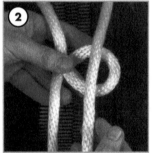

Keeping this loop open, place the right-hand rope over the P so it looks like a pencil in front of an eye.

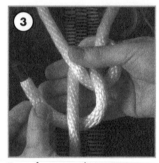

Transfer everything into your right hand, pinching the P together to maintain its shape. Now pass the right rope under (behind) the left rope.

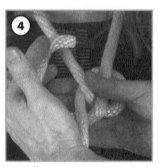

Pass the same rope over (in front of) the upper left rope. (Make sure your right hand still maintains the shape of the pencil in front of the eye.)

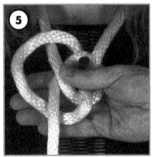

Lead this rope under the top of the P and out through the front.

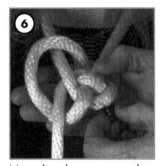

Now dive the rope over the "pencil" and down through the open loop on the lower right corner.

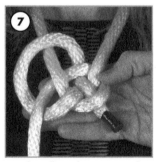

Finish pulling the rope under the lower right corner loop and continue pulling it through until the left-side loop closes to match the right.

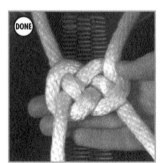

Adjust the ropes carefully throughout the knot to make it symmetrical. Do NOT try to tighten the knot by pulling on both ropes or it will collapse.

Trinity (Celtic) Knot

The Trinity Knot is a variation of a traditional triangle knot drawn by the ancient Celtic scribes. Elegant and complex in appearance, it is an excellent knot for a chest harness. The two corner loops are perfect for accepting each end of the ropes that come out the third corner when wrapped around the body. It's also the knot used to form the front/top portion of the Rope Panty.

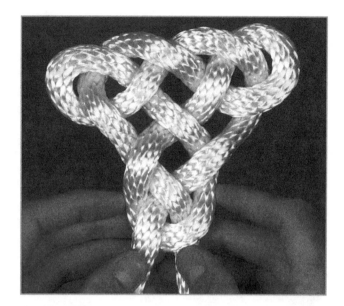

Rope length: Dependent on piece being tied
Rope diameter: ³/₈ inch to ⁷/₁₆ inch

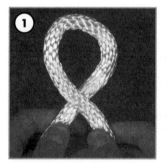

1 Begin by holding a small bight above your hands and twist the right-hand side of the bight over the left-hand side to create a counterclockwise loop.

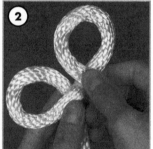

2 While pinching the first loop securely with your left hand, make a second small bight to the right, twisting it to create a counterclockwise loop just like the first.

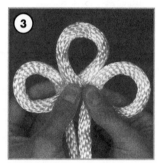

3 While holding the first and second loops securely with your left fingers, create a third small bight. Once again, twist it to make a counterclockwise loop just like the others.

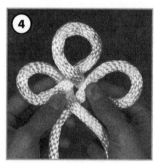

4 While supporting all three loops between both your thumbs and forefingers, cross the dangling rope on the left-hand side over the dangling rope on the right-hand side.

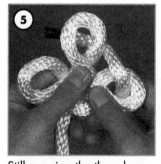

5 Still securing the three loops with one hand, fish the end of the dangling right-side rope up behind through the third loop. Pull the rope completely through. Then cross it behind the top loop.

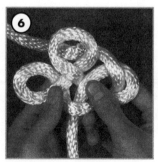

6 Poke the rope that passed behind the top loop through the second loop to create a small protruding bight. Now securely hold all the loops with your right hand.

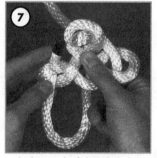

7 Fish the end of the dangling rope down through the front of the left-side loop and weave it through the small bight that protrudes from the top loop.

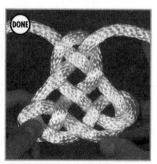

DONE There! Now you have a Celtic Knot—that looks as good in rope as it does on paper!

Butterfly Loop

Here's a great way to make a loop knot tied in a bight. It's secure, strong and easy to tie and untie. It also won't collapse or tighten when the parent line is under tension. It can also be used to isolate a damaged part of the rope. We like it because it looks prettier and more symmetrical than simply tying a double overhand knot in a bight, plus it lies flatter on the back of the neck for certain harnesses or the Rope Cage.

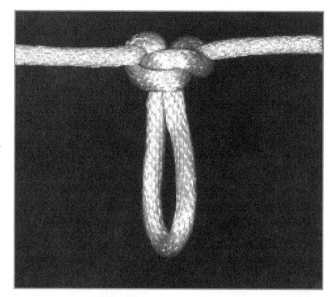

Rope length: Any length
Rope diameter: Any diameter

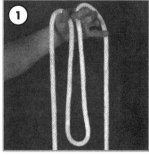

Pull a large bight through your hand, making the shape of the letter M.

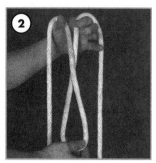

Twist the bight once... .

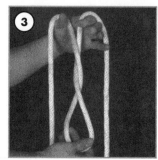

and then twice. (Note that the middle opening in the twists will be where you thread the bight through in Step 6.)

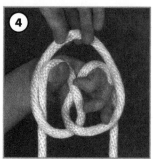

Pull the bight straight up and over the top of your hand. Keep an eye on the opening in the middle twist.

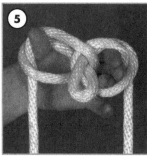

Pinch the bight and pull it through the opening (made by the second twist) from back to front.

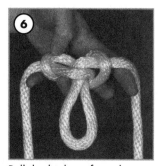

Pull the bight to form the loop...

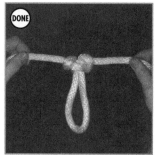

And tighten the knot by pulling the ends.

Cross Knot

The Cross Knot is a traditional decorative knot believed to have originated in Vietnam, however it was later learned and embraced by Chinese knot tiers. Today, it's tied around the world, used primarily as a decorative knot with nonslip properties. We like using this knot as a nice alternative to Square Knots on harnesses and other pieces like the Tortoise Shell Bodysuit.

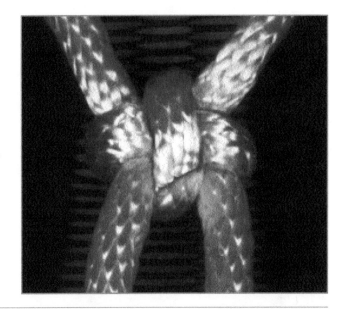

Rope length: Dependent on piece being tied
Rope diameter: ³/₈ inch to ⁷/₁₆ inch

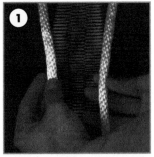

1 Begin by draping the middle of the rope around the back of your partner's neck.

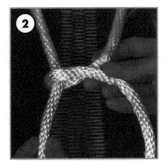

2 Wrap the right-side rope behind and over the dangling left-side rope. With your right hand, pinch the base of the bight to keep it horizontal.

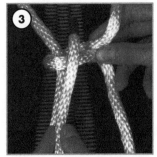

3 Bring the the dangling left-side rope up and over the front of the horizontal bight made in the right-hand rope...

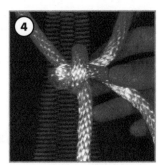

4 and drop it down behind the horizontal bight.

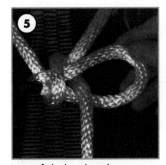

5 Now fish the dangling right-hand rope behind the adjacent dangling rope, and pass it through (under) the vertical loop created when the left rope wrapped over the bight.

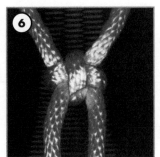

6 Pull the rope firmly through the vertical loop until a cross appears.

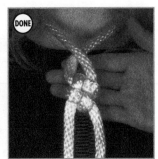

DONE If you flip the Cross Knot over, it looks like a woven diamond. You can achieve this woven diamond appearance in the front by crossing the ropes before you start Step 2.

Good Luck Knot

We jokingly claim this knot got its name because all who try to tie it are told "Good luck!" But in seriousness the knot is one of the simplest in an ancient Oriental series of increasingly elaborate knots know as "Crown Knots." Strong and stylish in appearance, the Good Luck Knot works well as a centerpiece on body harnesses.

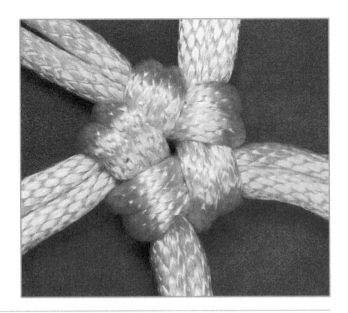

Rope length: Dependent on piece being tied
Rope diameter: ¹/₄ inch to ¹/₂ inch

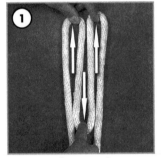

Place one finger at the middle of the rope and two fingers on the other side. Then pull your two fingers up past the one finger—to create two equal-sized bights.

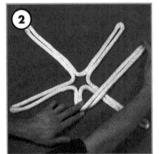

Spread the top two bights into a V shape. Form two more identical bights, one on each side of the downward ends. Lay the leading ends over the first (southeast corner) bight.

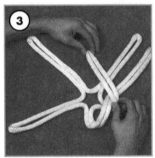

Then place the southeast bight over the pair of leading ends that just crossed it AND the northeast bight.

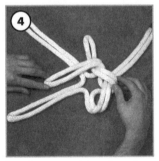

Lay the second (northeast) bight over the previous bight that just crossed it AND the northwest bight.

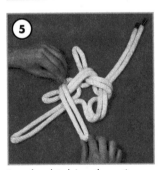

Lay the third (northwest) bight over the previous bight that just crossed it AND the southwest bight.

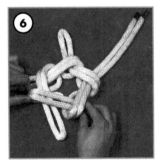

Now lay the fourth (southwest) bight over the previous bight that just crossed it—and tuck it through the loop created by the initial move.

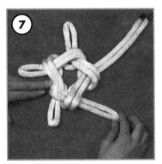

Carefully pull the two ropes associated with the open end and each of the four extended bights successively until the piece is snug.

If what you're looking at looks like the picture above, then you must have good luck!

Box Knot

The Box Knot is essentially the primary knot used to create decorative round mats, similar to the woven rectangular mats seen on doorsteps across America. Only difference: the Box Knot does not require repetitive weaving. Like the Double Coin Knot, it's an excellent flat knot for adorning a chest or as the basis for a body harness, since its four corner loops can be widened to take ropes from all sides.

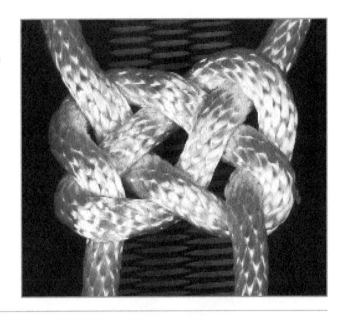

Rope length: Dependent on piece being tied
Rope diameter: $^3/_8$ inch to $^7/_{16}$ inch

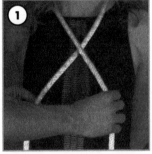

1 Beginning with the middle of the rope around the back of your partner's neck, cross the left-hand side over the rope on the right-hand side.

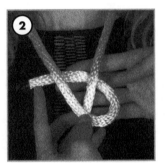

2 With one hand securing the point where the ropes cross, circle the right-hand rope counterclockwise and under the V made by the top ropes.

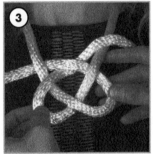

3 With one hand securing the piece, turn the left-hand rope clockwise and over the left side of the V, then weave it under the rope that crosses behind the V.

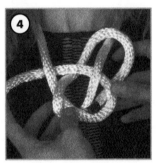

4 Pass the rope over the upper right rope. Then weave it under and through the loop on the right side.

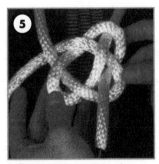

5 Pull the rope completely through this loop.

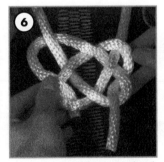

6 Now turn your attention back to the dangling rope on the left-hand side. Fish it down and through the front of the loop on the left side. Pull the rope completely through.

DONE Adjust the Box Knot so as to maintain its flat, square appearance.

Snake Weave

The Snake Weave is effectively a Box Knot stretched out through the same weaving techniques used to make belts or even straw hats or common braid. Clean and complex looking, the Snake Weave is primarily utilized in the creation of the Rope Panty.

Rope length: Any length
Rope diameter: ¹/₄ inch to ¹/₂ inch

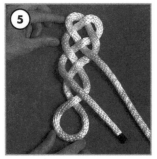

Starting from the end of a long outstretched bight of rope, twist the right-hand side of the bight over the left-hand side to create a loop that looks like a *U* over an *O* shape.

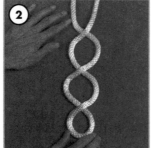

Along the desired length of your piece, make equal-sized openings by crisscrossing the left-side rope over (and the right-side rope under), to form successive twists.

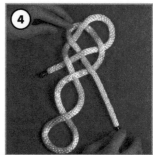

Rotate the rope on the left-hand side back toward the twisted bight and lay it diagonally atop the adjacent *O* loop, making sure to cross both the left and right of the loop.

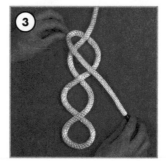

Then, rotate the rope on the right-hand side back toward the twisted bight, weaving it under both edges of the adjacent loop, but over the rope that crosses between.

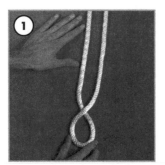

Repeat Steps 3 and 4 above until you...

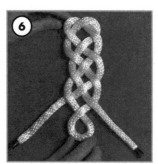

weave both ends of the ropes...

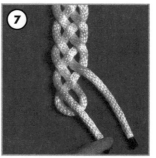

all the way back to the first loop at the end,

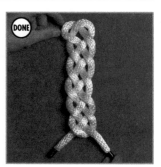

successfully completing the Snake Weave!

Cording Rope Ends

If you're ever at the ends of your ropes and wondering what to do, here's a neat trick. Cord the ends. Unlike ropes that are simply spiraled together, corded ropes resist unwinding themselves. By first twisting each rope within itself—before twisting it around the other rope—you can use the counter-twisting force to keep both ropes wound together. In fact, this is how traditional rope is made. It's also how you can make "rope" out of any fiber, even toilet paper!

Rope length: Any length
Rope diameter: Any diameter

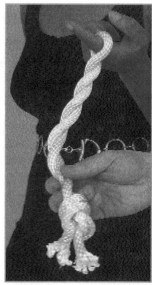

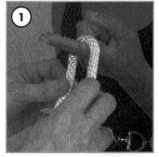

1 You can begin cording anywhere on a bondage design that you have two parallel ropes, preferably of equal length.

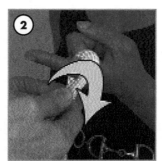

2 Twist the right-hand rope clockwise, about one quarter turn. (NOTE: If you are left-handed, you can twist the left rope counterclockwise and lay it over the right.)

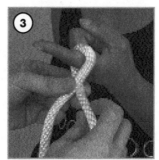

3 Lay this twisted rope over the left-hand rope, holding it tight at the cross-point with your left hand. Now the left rope will be on the right side.

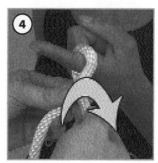

4 Again, twist the rope on the right clockwise...

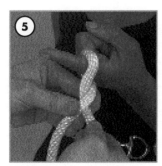

5 and lay it over the left, securing the most recent cross-point with your thumb.

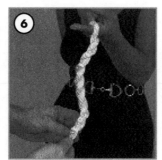

6 Repeat this process until you are at the end of your ropes (or at the point in your piece where you want to place another knot to continue).

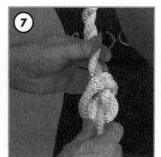

7 You can finish the cording by tying an overhand knot using the two parallel ropes. Alternatively, any finishing knot will do.

DONE This makes a wonderful leash and handle, especially when it is integrated at the end of a beautiful rope harness.

Chain Braiding

The chain braid is a convenient and effective way to shorten and store a length of rope. Once completed, the chain-braided rope can be tossed in bag or hung on a wall without fear of it tangling with itself or other nearby ropes. It can also be quickly and easily untied for use in the playroom!

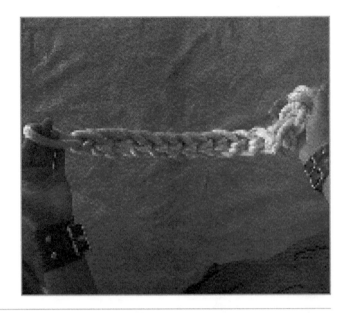

Rope length: Any length
Rope diameter: Any diameter

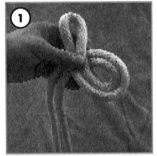

Begin by finding the middle of your rope and creating a bight, looping the rope as shown (counterclockwise and under the bight).

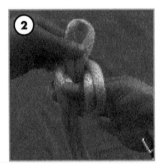

Put your finger through the eye of the loop you created and take hold of the two dangling ropes.

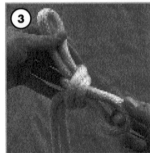

Pull the two rope ends through your loop and create a Double Slipknot.

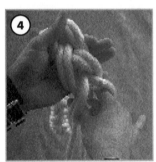

Now, fish your fingers through the new loop you created and again take hold of the two dangling ropes.

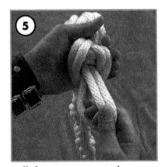

Pull the two rope ends through your loop, and repeat the operation until the chain reaches your desired length.

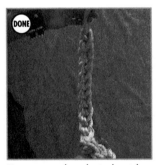

To prevent the chain braid from unraveling, thread the ends of the ropes all the way through your last loop.

The chain can be easily released by pulling the threaded ropes out of the last loop.

Pull the ends until all the Slipknots are released. Once all your Slipknots are out, you'll be holding the rope in a bight right at its middle, conveniently ready to tie!

Basic Bondage

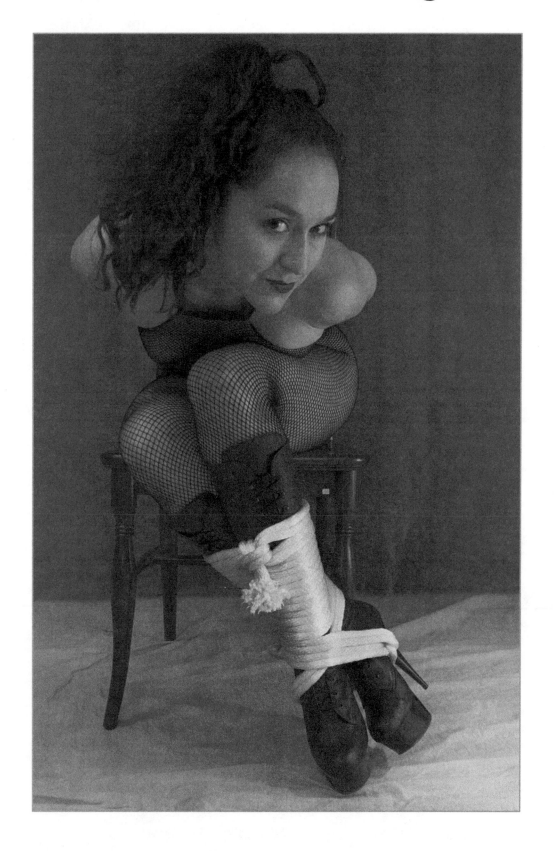

Cat's Paw

For centuries a staple knot for fishermen and sailors, this simple knot isn't really a knot, but just a series of twists. We find it perfect for tying single wrists or ankles to bedposts! It's superfast to tie, looks great, and doesn't tighten up when you don't want it to. No matter how hard your tyee pulls, it won't come loose, it won't cinch up, and it stays safe even through intense struggling (heaven forbid). Yet it's easy to loosen up and untie.

Rope length: 10 to 15 feet each
Rope diameter: $^{7}/_{16}$ inch to $^{1}/_{3}$ inch

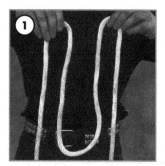

1 With both hands holding the rope about two feet apart, droop the middle of the rope down to form the shape of a letter M, as in "Mmmmm... bondage."

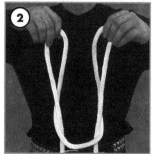

2 With both hands, twist the top loops of the M in opposite directions.

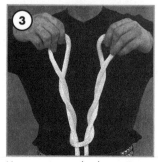

3 Keep twisting the loops an equal number of times. Four or five twists work nicely for the wrists.

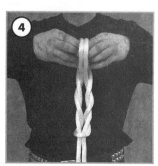

4 Now place the top loops side by side. Make sure the loops stay open.

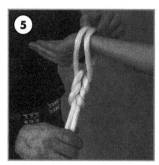

5 Holding them together, place both loops over your partner's hand and onto the wrist.

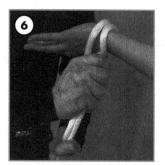

6 Tighten the knot by using one hand to slide all the twists up against the wrist, while holding the loose ends of the rope with your other hand.

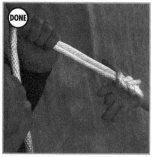

DONE "The wrist is history," as they say. Tie the ends around your nearest bedpost or other anchor point. Repeat these steps for the other wrist.

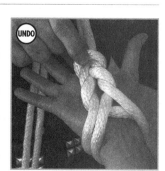

UNDO To undo this knot, simply loosen it by pulling on the very top twist. This will put slack in the twists and make it easier to spread the loops wide enough to slide them off.

Cat's Paw for Ankles

A simple application of the Cat's-Paw, the Cat's-Paw for Ankles is perhaps THE best way to quickly stretch and fix a person's legs apart securely upon a bed. Moreover, the tie allows for legs to be fixed in such a way that the tyee is unable to turn his or her toes inward—skillfully disabling a person's ability to "pigeon toe," or block (cough) your advances. Just so you know... the piece works best when the person tied is wearing boots!

Rope length: 15 to 20 feet
Rope diameter: ³/₈ inch to ⁷/₁₆ inch

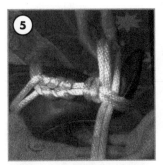

Begin the piece by first tying a Cat's-Paw.

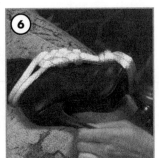

Be sure to make the loops of the Cat's-Paw large enough to easily slip around your partner's ankle.

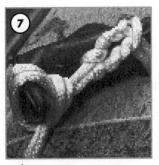

Once the loops of your Cat's-Paw are cinched snugly against your partner's ankle, bring the dangling rope ends toward the inside of your partner's arch.

Now bring the dangling rope ends under the front pad of your partner's foot...

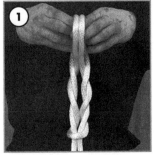

then, over and under the two ropes stretched along your partner's instep.

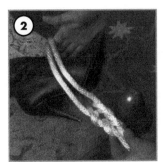

Adjust the piece so that all the rope is snug along the length of the foot...

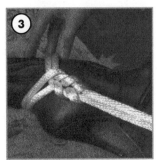

making sure to turn your partner's toe outward.

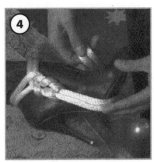

With what remains of your dangling rope, fix your partner's foot to the bed by tying your rope off to the leg of the bed.



Basic Wrap

One of the most useful bondage techniques is this Basic Wrap. Use it wrist-to-wrist, ankle-to-ankle, wrist-to-ankle, or even to secure an arm or ankle to the leg of a table or chair. It doesn't have to be rock-hard tight to hold, and it can even be loosened midscene without freeing your partner, so it's a more circulation-friendly technique to use even in long-duration play.

Rope length: 25 to 40 feet
Rope diameter: $^3/_8$ inch to $^1/_2$ inch

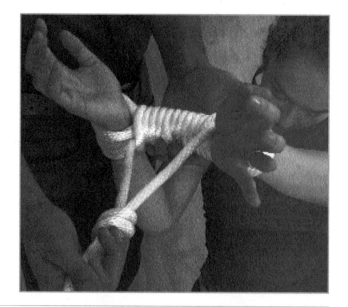

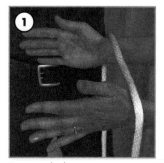

1 Start with the wrists apart, about two fist distances (or "fistances") wide. Lay the very middle of the rope atop both wrists.

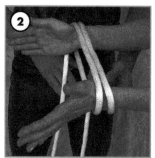

2 Wrap one end of the rope two times around both arms, toward the elbows.

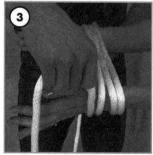

3 Wrap the other end of the rope two times toward the hands. (If you're using thinner rope, wrap more times in each direction, to distribute the pressure over a wider area.

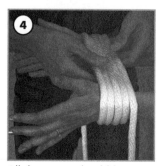

4 All the ropes should lie parallel and flat against the skin. None should cross. Otherwise, all the force would press against the wrist at one point, where the rope rolled.

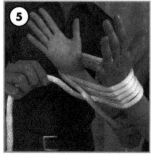

5 At the bottom, cross the "front side" rope with the "back side" rope, like you're tying ribbon around a package.

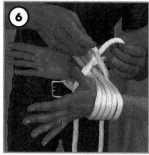

6 Pull both ends of the rope all the way around the wrist wrappings.

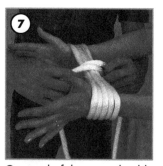

7 One end of the rope should now hang to the front (the hands), and one to the back (the elbows).

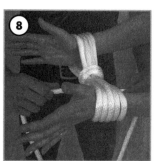

8 Now, tighten down the wraps. Working from the middle, you'll begin to wind each end of the rope toward the wrist.

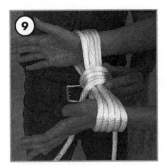

Wind one end of the rope around the wrapping, all the way to the wrist. (Be careful not to let the middle creep toward the other wrist.)

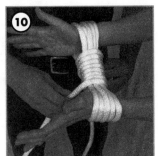

Now winding in the opposite direction, wrap the other rope toward the other wrist. (Bunching up the rope in your hand and unraveling as you wind helps you wrap faster.)

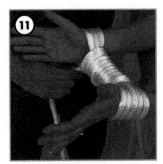

As with the first wrapping, none of the ropes should cross. To protect circulation, be sure you can fit one finger between the inside wrist and the winding.

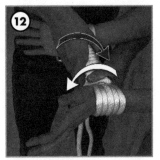

Tighten the piece by twisting the wrap, with each hand turning in the opposite direction. (Reverse the twist direction to loosen.) Add more winds if needed.

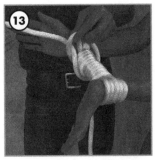

To secure the ends, lift the last loop of the winding and pass the end of the rope from the inside to the outside.

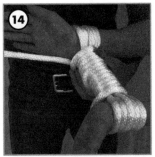

Tighten this down, being sure to maintain a finger space between the wrap and the wrist.

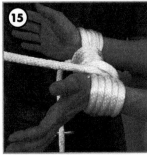

Secure the other wrist the same way. You'll notice that one end of the rope exits the wrap on the top, the other on the bottom. This is correct.

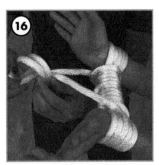

You can either use the loose ends to tie off one at a time, or you can tie both ropes together in a double overhand knot, like we've shown here.

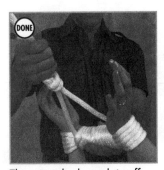

This triangle-shaped tie-off can be held up with the ends passing though an overhead eyebolt, or simply used to lead your partner around.

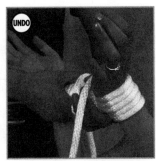

To loosen or undo the piece, simply twist both sides of the winding in opposite directions. (As before, twisting one way will tighten, the other way will loosen.)

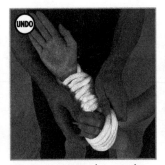

Keep twisting to loosen the wrap as much as possible. Then slide the loose wrap all the way toward one wrist to open the opposite cuff, and slide the hand free.

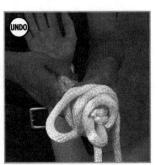

Now slide the loose wrap all the way off the empty end to free the other hand. Amazingly, the empty rope will be left without any tangles, just two loose overhand knots.

Rope Shackle

This is a perfect tie for restraining a single wrist to any fixture, such as the arm of a chair. Its multiple loops stay secure and comfortable under any strain. It can also be used to tie other limbs, such as knees, to armrest posts for chair bondage and other techniques.

Rope length: 10 feet or more
Rope diameter: ¹/₄ inch to ¹/₂ inch

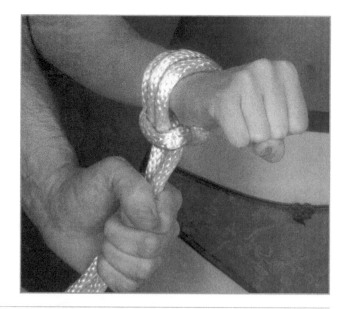

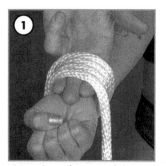

1. Place three fingers of the back of your hand along the wrist of your partner. From the middle of the rope, make four wraps around the arm and your fingers. Keep ropes flat.

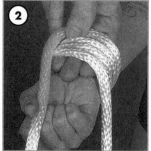

2. Stick your thumb between the first and second ropes and make an *L* shape by crossing the left-most rope over all the others.

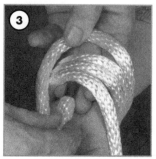

3. Take the end of that rope and pass it under all the ropes except for the first rope (itself).

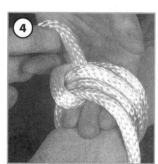

4. Pull the rope out over the first rope (itself) and all the way through. Let it drop down the other side, toward you.

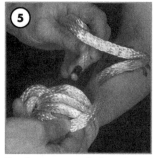

5. Do the same with the other end of the rope, making a *7* and crossing over all the ropes, then under all three ropes and then make it come out over itself.

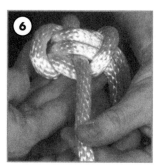

6. Pull the rope all the way through the knot. Done correctly, the knot should look symmetrical.

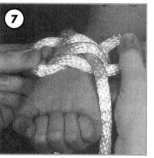

7. Tighten the shackle by pulling on the "ear" loops until the wraps are secure around the wrist.

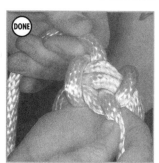

DONE. Tighten the knot by pulling the ends of the ropes to shrink the "ears" tightly back into the knot. (To maintain circulation, the shackle should be loose enough to accept one finger under it.)

Ankle Wrap

This is the best ankle wrap we know! Not only does it look awesome on a pair of gams, it's more incapacitating than other ankle tying techniques. That's because with the ankles firmly crossed, there's no way for the tyee to stand up and maintain balance. It's also quite comfortable. It works best over a pair of heeled boots. (Actually, we think all bondage is best when the tyee is wearing boots. Corsets too. Oh yeah, and black latex opera-length gloves.)

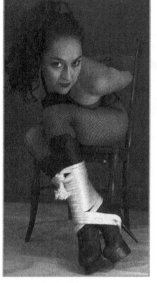

Rope length: 30 to 40 feet
Rope diameter: ³⁄₈ inch to ⁷⁄₁₆ inch

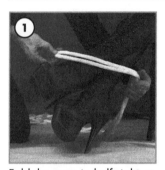

1 Fold the rope in half right at the middle to form a bight. Pull the bight over the top foot—in the direction the toe is pointing. Think: *The toe points the way.*

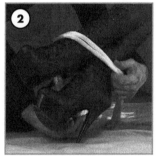

2 Pull the bight under both arches to the edge of the bottom foot.

3 Make sure the bight does not rise up the side of the foot.

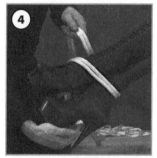

4 Holding the bight with one hand, use your other hand to draw both long ropes around the back of the ankles and down across the foot.

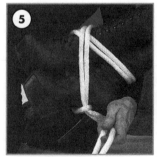

5 Thread the ropes down through the bight at the bottom of the foot...

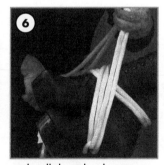

6 and pull them back up over the top of the foot, retracing the path of the previous ropes. Keep the ropes parallel. Do not let the pair twist or roll.

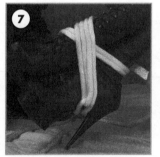

7 Bring the ropes around the back of the ankles again, laying them right beside the previous ropes. Keep the ropes tight throughout the piece—the firmer, the better.

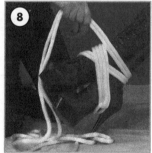

8 Now just start wrapping the ropes around and up the legs, keeping the ropes flat and side by side.

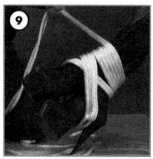
Keep on wrapping up the leg.

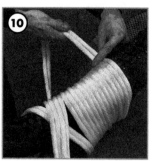
When you have only enough rope remaining to wrap twice more, stop, and hold your finger at the top...

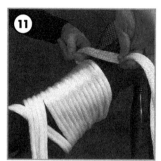
then double back the ropes, and wrap once in the opposite direction.

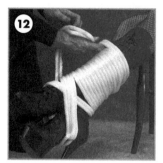
Fish the ropes through the top of the new bight where your finger is holding the ropes.

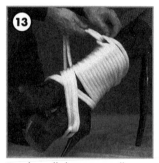
Firmly pull the ropes all the way through the bight and pull them back in the opposite direction.

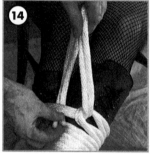
Fish the ends under the top two ropes...

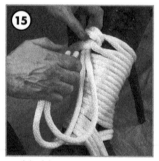
and hold an opening at the top...

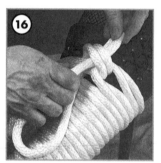
and pull the ends of the rope through this opening to tie off the piece.

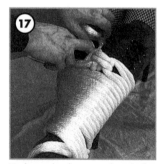
Tighten the knot and tuck the remaining ropes between the legs.

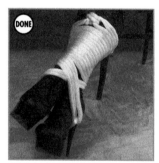
Oh yeah!

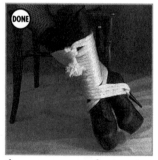
If you wanna get fancy, trim off the ends of the ropes below the knot and fray the ends to make little tassels.

This wrap looks excellent from any ankle... um, we mean angle.

Three-Loop Quick Harness

Here's a quick chest harness that looks good, ties in about a minute, and lets you hold on to your partner with a nice cord on the back.

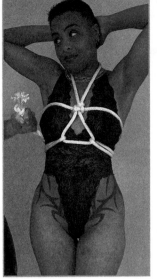

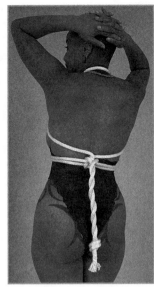

Rope length: 20 to 30 feet
Rope diameter: ³/₈ inch to ⁷/₁₆ inch

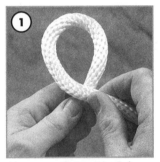

About one foot to the left of the very middle of your rope, make your first loop by laying the right-hand rope over the left rope.

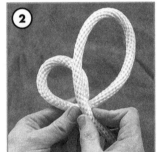

Make your second loop the same way, but make it about four times the size of the first loop. (This loop should be sized just large enough to fit over your partner's head.)

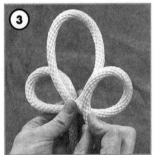

Now make the third loop, right-over-left, the same way and the same size as you made the first loop.

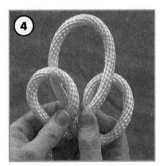

This is the trickiest part: REVERSE the order of the "stair-stepping" of the loops so that the left loop is now atop the middle loop and the right loop is under the middle loop. Don't let it untwist.

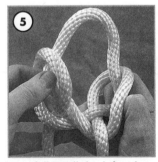

Carefully pull the left side of the middle loop through the left loop—at the same time you pull the right side of the middle loop though the right loop.

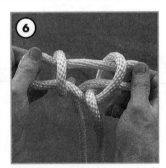

Steadily pull the loop to both sides until the left and right loops collapse and tighten themselves into a knot in the middle, leaving you with a new loop on each side.

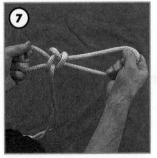

Carefully pull on the right-side loop in such a way that it grows while the other loop shrinks to about the diameter of a soda can.

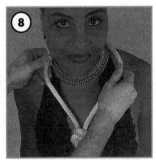

Lay the large loop over the head of your partner.

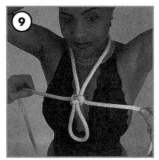

Adjust the size of the loops so that the knot is in the center of the chest above the breast line. Pull the ropes to each side around to the back.

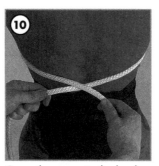

Cross the ropes in the back…

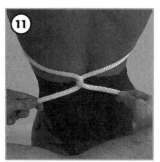

and twist them back in the opposite direction to form an X. Then bring each rope around to the front. Pull these ropes pretty tightly to ensure a snug harness.

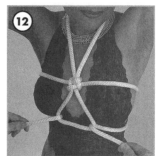

Bring both ropes to the front and pull them all the way through the small loop and back around to the back. Maintain tension in the rope to keep a snug fit.

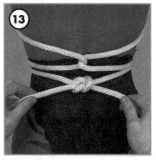

Bring the ropes to the back. Keeping them as tight as possible, tie them together using a Square Knot.

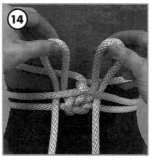

Pull each rope up and through its respective side of the X in the ropes above.

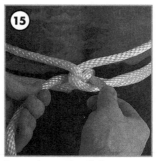

Bring the ends all the way through so that the Square Knot is now behind the X.

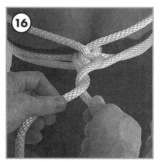

Make a harness leash by cording the ropes together, twisting each rope clockwise while you twist it around the other rope in a counter–clockwise corkscrew pattern.

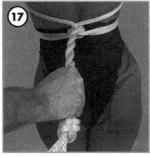

Tie an overhand knot at the end of the ropes and cut off the excess rope to make a nice tasseled handle.

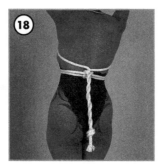

The back of the piece is simple and secure.

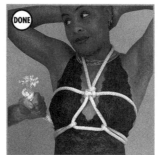

The front of the harness is tight and secure, and it looks elegant and much more complex than it actually is.

Dragonfly Sleeve

Here's a beautiful technique for restraining the arms behind your partner's body—without investing in an expensive leather "arm sock." It also has the nice side effect of projecting your partner's chest forward for your viewing and playing pleasure. You can also raise the arms up for unobstructed aim, or tie the piece down for intense upper body restriction. And although it looks like a lot of knots, you can untie the whole piece in under ten seconds!

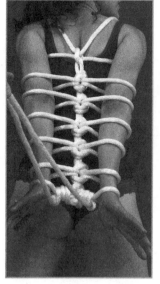

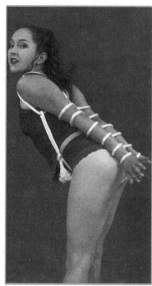

Rope length: 40 to 50 feet
Rope diameter: ³/₈ inch to ¹/₂ inch

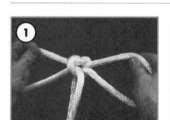

1 Start with a Bow Tie Knot. Pull the loops to make them wide enough to fit over your partner's shoulders.

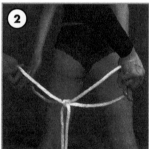

2 Have your partner stand with arms back and parallel, about shoulder width apart. Now slip the large bow loops up your partner's arms.

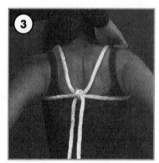

3 Slide the loops up the arms and over the front of the shoulders.

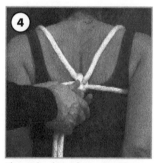

4 Place the knot between the shoulder blades and pull the ends of the rope to tighten the loops around the shoulders.

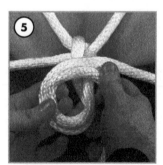

5 Just below the knot, take both ropes together and make a clockwise turn, with ropes on top (not behind).

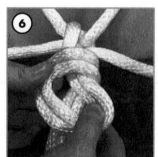

6 Press the hanging ends behind the loop…

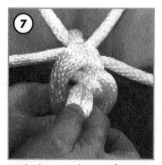

7 grab them with your fingers from the front and pull the ropes toward you through the loop. This creates a Double Slipknot.

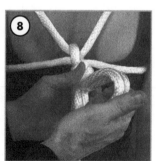

8 Keep pulling both ropes through the knot to create a pair of loops. Tighten the knot by firmly pulling on the top sides of the loops.

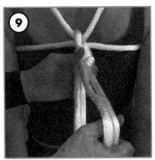
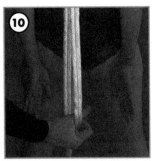
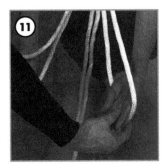
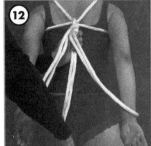

Holding the rope with one hand, make the loops larger by pulling on the lower sides of the loops.

Make the loops long enough to pass over the hands.

Slip each loop over one of the wrists.

Holding the knot with one hand, now pull the loose ends of the rope to tighten the loops.

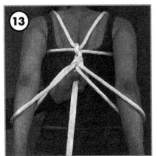
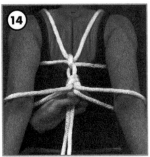
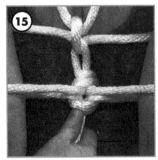
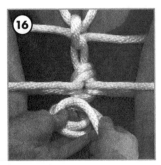

As you pull, let the loops rise up over the arms.

Keep pulling until the loops are horizontal.

For best results, tighten the central knot of the slipknot you just finished, and start the next slipknot as close to the previous one as possible.

Repeat the previous steps: loop the ropes clockwise...

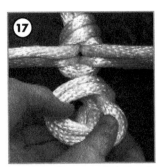
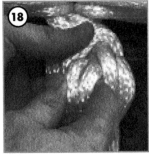
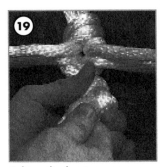
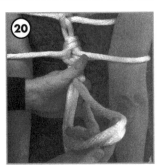

bring the loose ends behind the loop...

pull the ropes through the loop to form the Double Slipknot...

tighten the knot...

make the loops bigger...

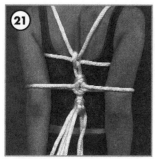

bring the loops down to the hands...

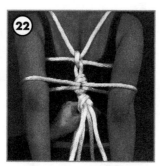

pass them over the hands...

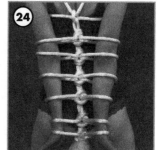

and tighten around the arms. (Get the idea?)

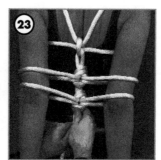

Repeat the previous steps until you've reached the wrists (or you're at the end of your rope).

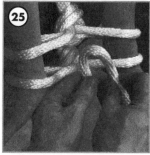

To secure the piece, pass one end of the rope around one of the loops...

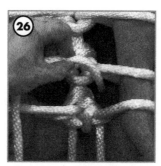

and start wrapping the rope around the loop.

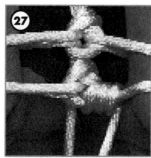

Continue wrapping until you are near the wrist.

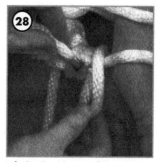

Lift the last loop of the wrap and pass the end of the rope through it, from the inside to the outside.

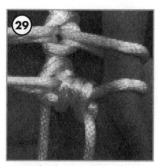

Now do the same on the other side of the center knot.

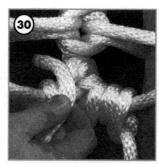

Wrap the left rope around the left loop.

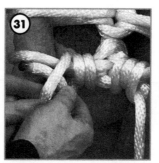

Lift the last loop of the wrap and pass the end through it...

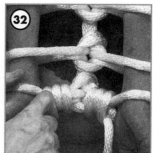

and tighten loosely.

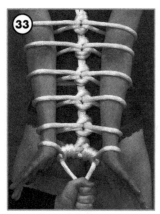

33 Now the piece is secure.

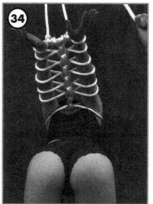

34 If you wish, pass the ropes through an overhead eyebolt and raise your partner's arms.

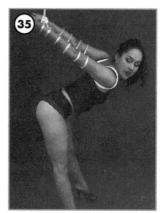

35 Mmmmm.

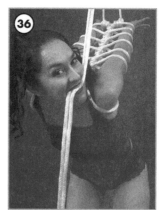

36 Yummmy!

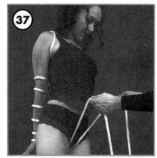

37 If you wish to secure the piece onto the body, start by bringing the ropes under the crotch to the front.

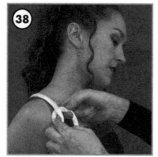

38 Pass one end under the rope that comes over the shoulder.

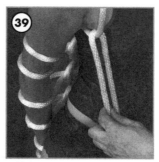

39 Pull this rope all the way through under the arm.

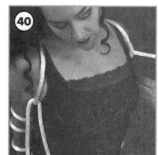

40 Repeat this with the other rope on the opposite side.

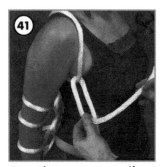

41 Cross the rope over itself...

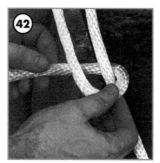

42 and bring it under both ropes.

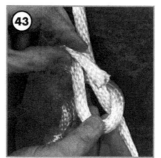

43 Feed the end of the rope down the front through the loop, thus creating an overhand knot around the original rope.

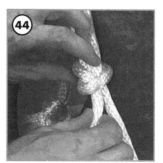

44 Tighten this knot onto the rope that passes through it. This provides the friction needed to secure the knot when you slide it.

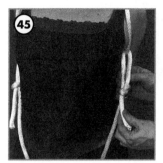

Repeat this on the other side.

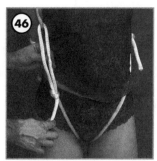

Holding the inside rope with one hand, slide the knot down the rope by pulling on the end of the knotted rope.

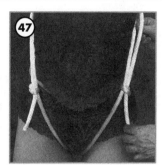

Pull the rope on the other side to match. It's like tightening suspenders (or "braces" for our readers in the U.K. or Commonwealth).

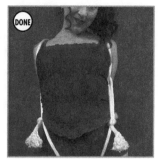

This pulls down the loops around the shoulders, keeping them from slipping off. It also makes your partner "hunker down" and feel more restricted.

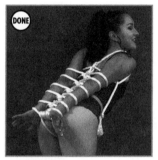

It looks nice, too!

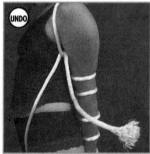

Undoing the Dragonfly Sleeve is easy. First untie the overhand knots around the front ropes.

Drop them free, back under the crotch.

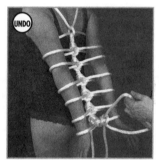

Untie all the wraps around the bottom wrist loops.

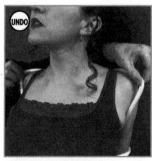

Slip the top loops down off the shoulders.

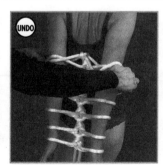

Then slide all the loops down the arms at once...

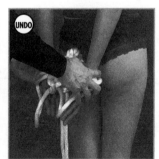

and pull the entire bundle off the wrists.

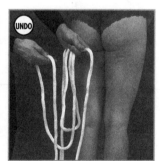

Because all the loops are slipknots, you can simply pull on the ropes and all the knots will disappear like magic!

Decorative Bondage

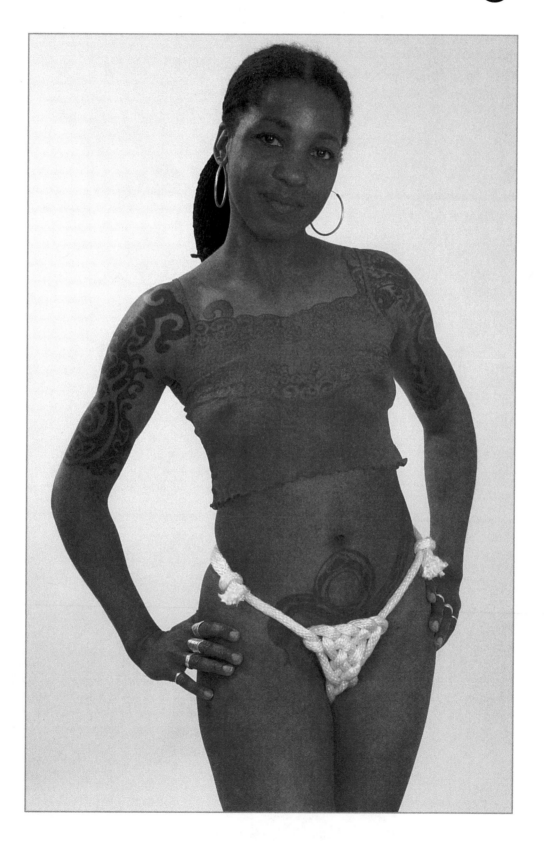

Rope Corset

One way to use rope to spice up any outfit is this beautiful rope corsetry technique, first made famous by Lou Duff in San Francisco. The clean "checkerboard" boning on the front can be accented by circling additional weaves around it. The back remains smooth and flat. It's also a wonderful piece that you can tie onto yourself. The same technique is used to create Rope Gauntlets.

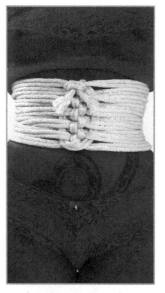

Rope length: Approximately 50 to 60 feet, depending on diameter of rope (and waistline)
Rope diameter: $1/4$ inch to $3/8$ inch

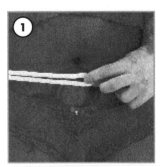

1 Make a bight at the very middle of the rope and hold it at the front/center where you want the bottom of the corset to sit below the waist.

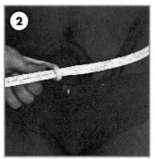

2 Draw both ropes through this bight at the front.

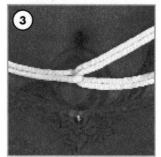

3 Pull both ropes back in the direction they came from. Wrap them all the way around the back, layering them flat against the skin, right above and against the previous pair.

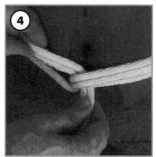

4 Now draw the two ropes down through the new opening made when they were doubled back. Adjust the tension here to the tightness desired for the piece. Don't leave it loose.

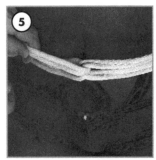

5 Again, pull both ropes back in the direction they came from.

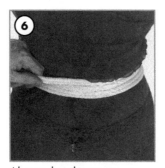

6 Always lay the ropes flat against the skin and the previous pair. Avoid making gaps or twisting the ropes. Keep the tension firm and consistent throughout the winding.

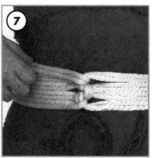

7 As before, always draw the two ropes down through the new opening made when they were doubled back.

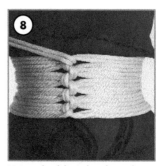

8 Keep doubling back and layering the ropes until you are at the desired height, or until you run out of rope.

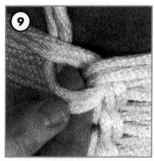

To tie it off, double back the ropes again, but pass them under and up behind the top pair. Use your finger to hold an opening.

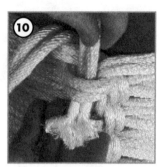

Pass the ends of the ropes down through this opening.

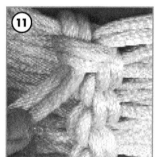

Pull the ropes completely through this opening and tighten everything down. You can either cut off the excess here, or go to the next step to do a weave.

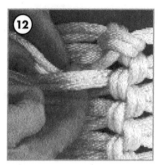

You can weave the excess rope around the midline by passing the ropes under and over each alternating pair of ropes.

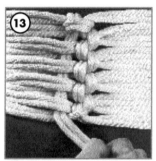

As you alternate weaving over and under each pair, keep the ropes flat.

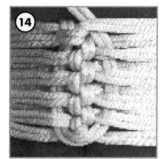

Continue the weave up the opposite side. If you have even more excess length, you can continue weaving down the other side, against the first one.

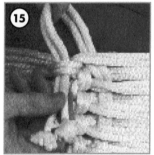

To tie off the weave, pass the ends of the ropes down through the knot that secured the piece.

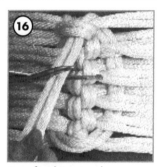

As a finishing touch, you can cut off the ends of the ropes to make tassels, or...

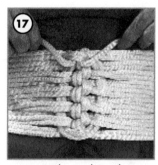

you can also tuck each rope behind the corset to hide the ends cleanly.

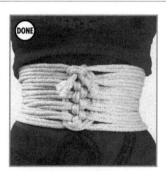

The resulting medallion design is dazzling.

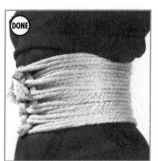

The front makes a nice contrast to the smooth back of the corset.

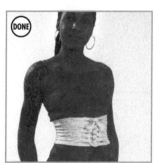

Like we say, waist knot, want knot!

Rope Gauntlet

Proving the versatility of the Lou Duff Rope Corset, a Rope Gauntlet is simply rope corsetry tied upon the forearm. Still, as far as decorative ties go, Rope Gauntlets are perhaps the most elegant forearm ornamentation for men and women alike—when it comes to ornamentations made of rope, that is. The same technique can be used for wrapping the calves (though we don't recommend it for roping cattle).

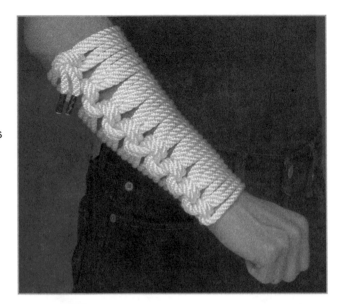

Rope length: 30 to 40 feet
Rope diameter: ¹/₄ inch to ³/₈ inch

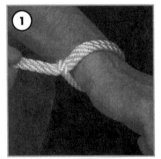

Begin by wrapping a bight around the wrist and pull both ropes through the bight.

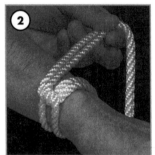

Then, double back the loose ends of your rope upon themselves...

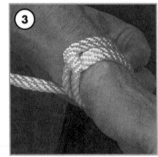

and around your partner's wrist. Stop at the doubled loop you created.

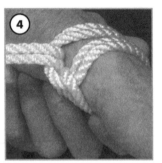

Now tuck both loose rope ends of your rope under, up and through the doubled loop.

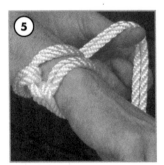

Again, double back the loose ends of your rope upon themselves...

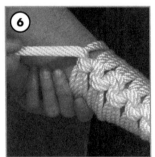

and repeat the previous steps until you reach the top of your partner's forearm.

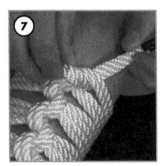

To complete the piece, simply tuck the loose ends of your rope under, up and through the topmost two lines of rope on the forearm—leaving a small loop when you do.

Finally, tuck the loose ends of your rope over the topmost two strips of rope and through the small loop you created.

Trinity Knot Bra

The Trinity Knot can turn an otherwise simple harness into a work of art. Plus, it lifts and separates! Tied with longer rope, this piece can serve as the beginning of an intricate body harness with unlimited creative possibilities when used in conjunction with additional knots (like the Double Coin) and wraps. The Trinity Knot can also be left tied in the rope, making future harnesses instant and easy to repeat.

Rope length: 15 feet or longer
Rope diameter: Any

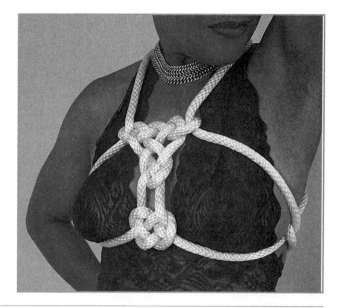

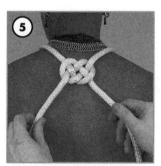

1 Start with a Trinity Knot tied in the very middle of a length of rope. Below the Trinity Knot, add space below the breasts by adding a Double Coin Knot.

2 Bring one end of the rope up its respective side and feed it through the top corner loop of the Trinity Knot, up from behind.

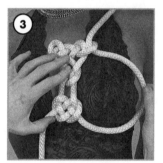

3 Leave just enough slack to form a large loop that fits around the breast.

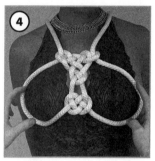

4 Repeat the previous steps for the other side. Keep both of the loops evenly sized and symmetrical.

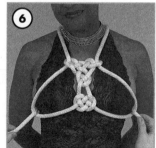

5 Bring both ropes over the shoulders and secure them with another Double Coin Knot, just below the neck.

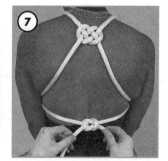

6 Bring each rope under the arms and pass it through the outside corner of the breast loop on its respective side.

7 Double back each rope so it comes back under the arms. Tie it securely using a Square Knot or a Double Coin Knot.

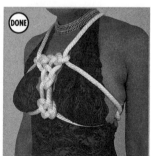

DONE Use this bra as a beautiful adornment for a simple outfit, or use it as the basis for a playful bondage harness.

Rope Panty

The Rope Panty is the ready-to-wear result of combining the Trinity (Celtic) Knot and the Snake Weave. Both beautiful works of rope in their own right, together the two make for a stylish decorative rope piece that's sure to grab attention!

Rope length: 30 to 40 feet
Rope diameter: $^3/_8$ inch to $^7/_{16}$ inch

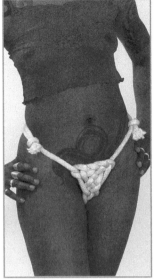
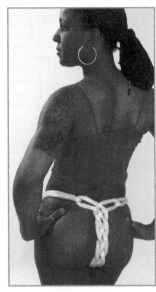

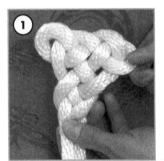

Begin the piece by first tying a Trinity Knot.

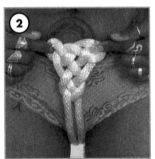

Have your partner hold the Trinity Knot in place slightly below her waistline, with the rope ends between her legs.

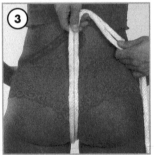

Pulling the loose ends of your rope up her backside, note the point on the ropes that reaches the small of her back.

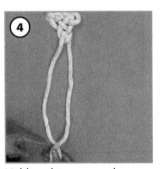

Holding this measured distance with your thumb, have your partner let go of the Trinity Knot. Carefully take your piece onto the floor.

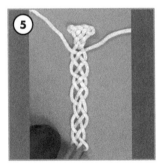

From your measured distance up to the base of the Trinity Knot, make a Snake Weave. Once your Snake Weave is complete…

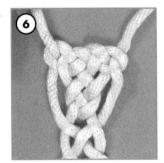

weave each loose end of the rope through the corner loop of the Trinity Knot. NOTE: the end that emerged on top should pass from below the loop, opposite the other.

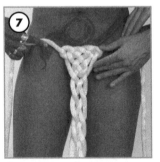

Once again, have your partner hold the Trinity Knot in place between her legs and slightly below her waistline.

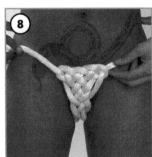

Bring the end of the Snake Weave back between her legs…

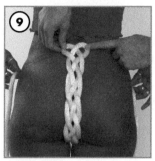

and up her backside to the small of her back.

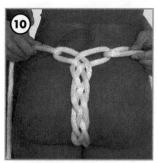

Take the loose ropes and tuck each end under and up through the corresponding loop at the end of the Snake Weave.

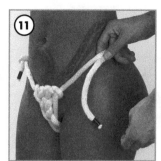

Approximately halfway between the small of your partner's back and the front of the piece…

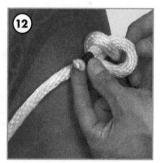

tie a sliding overhand knot as in Steps 1 through 3 of the instructions for the Fisherman's Knot.

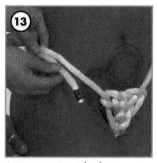

At approximately the same location but on your partner's opposite hip…

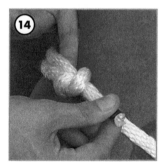

repeat Steps 1 through 3 of the Fisherman's Knot.

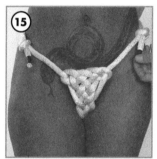

Adjust the piece by moving each of the respective sliding overhand knots back and forth.

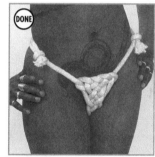

Once the piece is comfortably in place, you can snip the rope ends and fray them into tassels to add a little more flair!

Good Luck Knot Harness

The Good Luck Knot Harness is a sturdy, clean and elegant piece. Compared to the harnesses sold in upscale fetish retail stores, it makes for a far more reasonably priced (the cost of the rope) way in which to fit a partner. Its lines place focus on the chest, so it's a great adornment for men or women. Plus it provides handy-dandy holds for gripping.

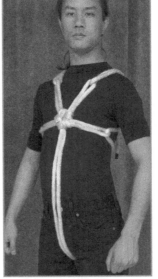
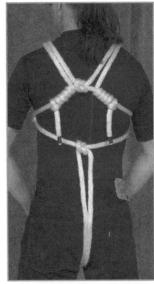

Rope length: 40 to 50 feet
Rope diameter: $^3/_8$ inch to $^7/_{16}$ inch

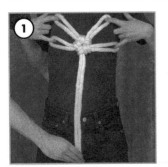

1 Begin the piece by first tying a Good Luck Knot. Be sure to make each of the closed loops of your Good Luck Knot about the length of a large hand.

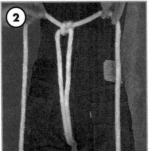

2 Have your partner hold the Good Luck Knot across the chest. Bring the loose ends down the front, between the legs and up around the backside. Tie a Square Knot halfway up.

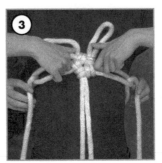

3 Bring each length around toward the lower loops of the Good Luck Knot. Then tuck the ends under, up and through each respective loop.

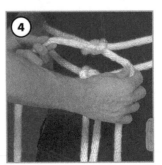

4 Bring the ropes back to the back, snugly. Once the loose rope ends are lined up with the spine, tie another Square Knot above the previous one.

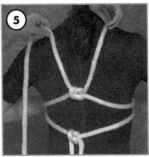

5 Bring the loose rope ends up the back and over each of the shoulders.

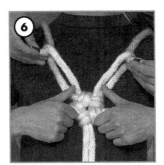

6 Tuck both loose rope ends under, up and through their respective top loops of the Good Luck Knot.

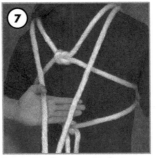

7 Bring each rope down its respective side of the back, making sure to pull the piece snugly as you do so.

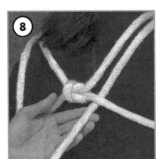

8 Thread each respective rope end under the lower part of the rope X on your partner's back.

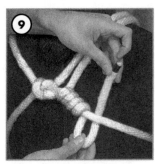 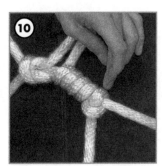 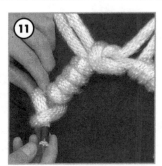 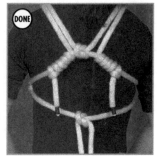

Then wind the loose rope four to five times around its leg of the X, leaving a small open loop at the end of the coil.

To tie off the rope, simply tuck each loose end of the rope down through the small open loop you left at the end of each wind.

Repeat the previous steps to compete the other side.

The result is a clean back and a decorative harness style on the front!

Tortoise Shell Bodysuit

Here's a variation on the basic diamond pattern "rope dress" popular in basic Japanese Shibari bondage. The version shown here uses simple overhand knots, but you could use the Double Coin Knot just as well for a more decorative piece. The Tortoise Shell is more than a pretty piece. It makes a wonderfully functional torso harness that's rich with hand holds for grabbing your partner. Plus, it still maintains accessibility for even more fun ideas.

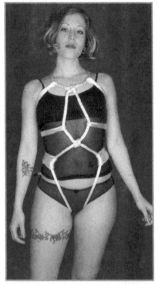
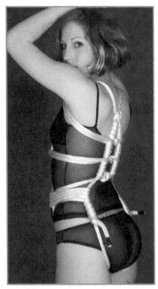

Rope length: 50 to 80 feet
Rope diameter: ³/₈ inch to ⁷/₁₆ inch

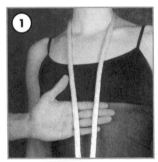

1 Start with the middle of the rope around the back of your partner's neck. (Come on, you should know this by now!)

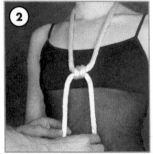

2 Just below the breast line, tie a Square Knot or a Double Coin Knot or even a Cross Knot.

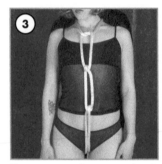

3 Tie two more knots, each at an equal distance down along the front.

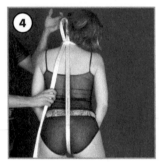

4 Bring both ropes under the crotch and up the back. Thread them under the rope that's around the neck, pulling the ends through.

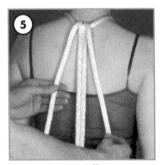

5 Pull each rope off to its own respective side...

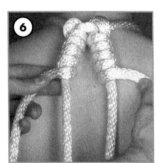

6 and begin winding each rope around itself, so that it looks kind of like a noose. Each rope should be wound from the inside to the outside (in opposite directions).

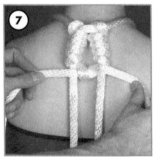

7 After about four or five turns, tie the ropes together with an overhand knot. Make sure both rope ends come out on top of (not under) the vertical ropes.

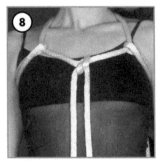

8 Coming from under the arms, thread each rope under the vertical ropes at the front, above the first knot. Then pull them back under the armpits.

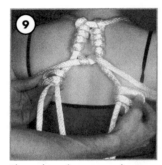

Thread each rope under its side of the vertical ropes on the back, starting below the previously tied overhand.

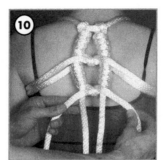

Just like above, wind each rope around itself, four or five turns, and secure it with an overhand.

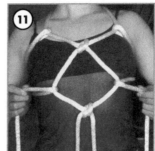

Bring each rope to the front and thread it under its side of the vertical ropes, between the first and second knot. Pull each rope around to the back.

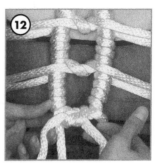

Just like before, wind each rope around itself, four or five turns, and secure it with a Square Knot. The ends of the rope should come out in front of the ropes.

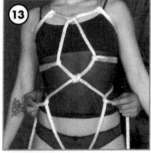

Bring each rope to the front and thread it under its side of the vertical ropes, below the second knot. Pull each rope around to the back.

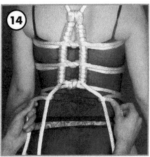

Thread each rope under its side of the vertical ropes on the back, below the previous Square Knot.

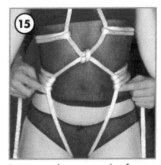

Bring each rope to the front and thread it under its side of the vertical ropes, layered just below the previous rope, then back to the back. Repeat this four or five times.

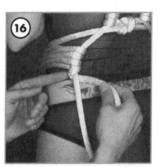

Tie each rope off at the back by winding it once around the vertical rope.

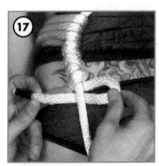

Then, bring the end back under the rope to form a small bight.

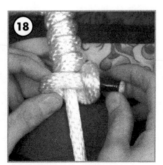

Bring the end of the rope over the vertical rope and thread it through the small bight...

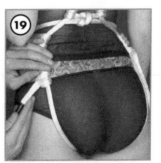

and tighten it. Do this to tie off the rope on the other side, too.

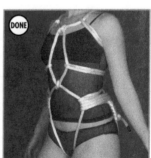

Now you have a beautiful piece that gives you many places to hold, especially when you're in a touchy situation!

Dominance Bondage

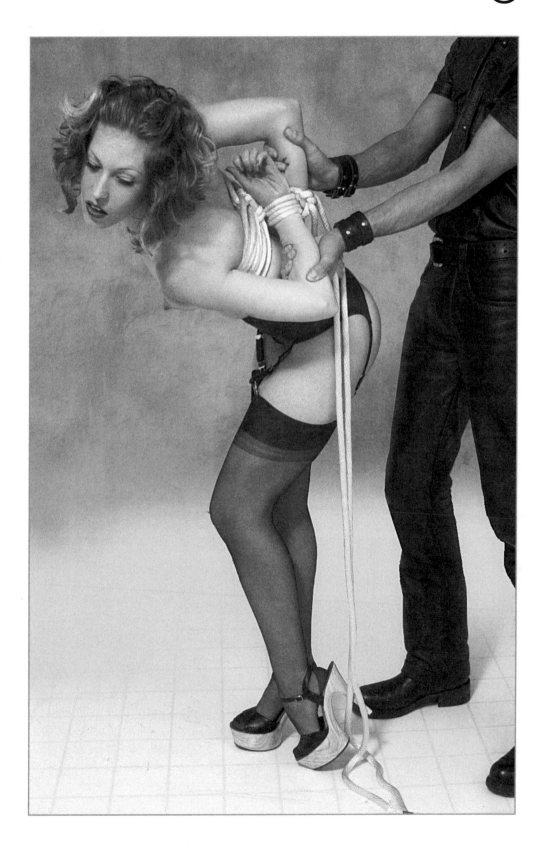

Over & Back Harness

The Over & Back Harness is one of the best ways to keep someone's arms and hands immobilized and out of the way. Still, this tie should not be used on partners who are new to bondage or have poor circulation. Instead, it should be saved for those annoyingly squirmy, flexible bottoms who believe they can get out of just about everything.

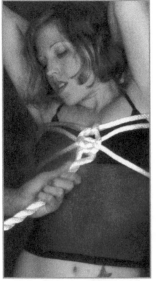
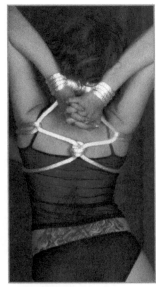

Rope length: 30 to 40 feet
Rope diameter: ³/₈ inch to ⁷/₁₆ inch

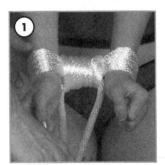

1

Begin the piece by first tying your partner's wrists in a Basic Wrap.

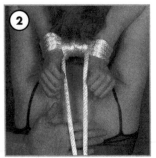

2

Bring your partner's wrapped wrists over the back until both hands are behind the tops of the shoulders.

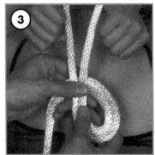

3

Gather the dangling rope together and tie a double overhand knot between your partner's shoulder blades. Do this by turning the rope pair up and under itself...

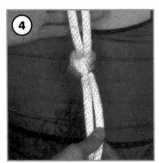

4

and pulling both ropes through that loop until the knot is snug.

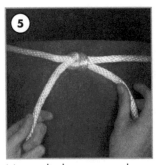

5

Now split the ropes and bring each rope around to the front of your partner's body. Where both ends meet in the center of the chest, snugly tie a basic Square Knot.

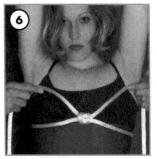

6

Flip each respective end of the dangling rope upward to cross your partner's chest like an X.

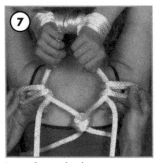

7

Now bring both respective ends around to the back. Weave them under each of the ropes in line above the overhand knot, pulling the ropes all the way through.

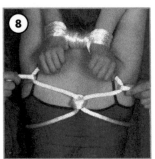

8

Pull the ropes apart to form a diamond shape, pulling your partner's wrists down to the level of the shoulders.

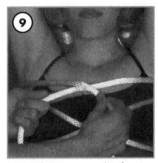

Bring the ropes to the front, above the breast line. Tie them together snugly with another square knot.

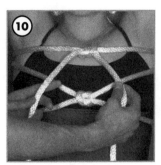

Weave each end of the rope over the top two arms of the X...

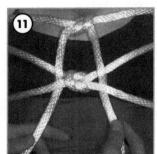

and under the bottom two arms of the X that crosses the chest.

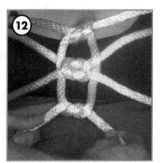

Under the bottom two arms of the X, tie an overhand knot (or really just the first half of a Square Knot).

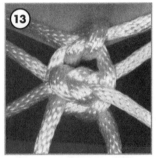

To tighten the piece, pull this knot snug until the both Square Knots, top and bottom, meet.

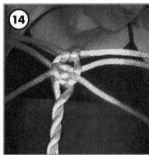

The remaining rope can be corded to create a leash.

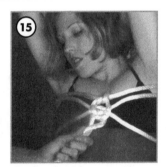

This leash makes a nice handhold for controlling your partner.

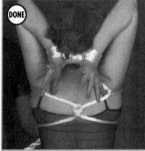

The diamonding method on the back is what makes it so difficult for submissives to squirm their arms over their heads to get their wrists to the front.

Japanese Pearl Harness

This piece is our modification of a traditional Shibari-style Japanese chest harness. Usually this harness would wrap around the arms as well as the chest, but we like to save binding the arms for after the torso piece is complete. This style is named "Pearl" because the pinching of the breasts between the ropes resembles a pair of pearls. If you find before you a pair of pearls as perfect as these, you'd be quite the lucky one indeed!

Rope length: 30 to 50 feet
Rope diameter: 3/8 inch to 7/16 inch

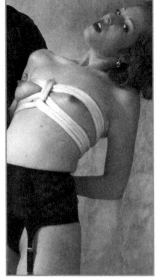
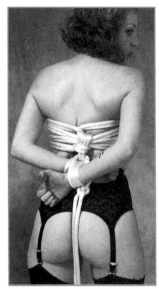

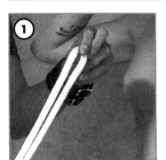

1 Start with a bight in the very middle of your rope.

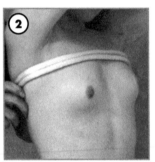

2 Wrap the pair of ropes above the breast line, bringing the bight around to the center of the back.

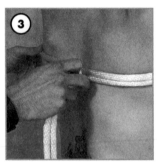

3 Pull the ropes all the way through this bight. Keep the bight centered on the spine.

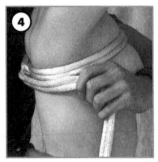

4 Adjust the tension to make the wrap firm (but not uncomfortably tight). Double back the ropes, wrapping them back around to the front of the torso.

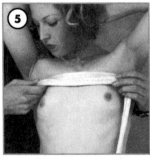

5 Layer these ropes in a line right below the previously wrapped row, keeping them flat against the skin and up next to the row above them.

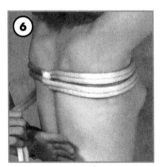

6 Keeping tension firm and consistent, continue wrapping these ropes around the back.

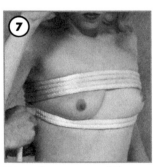

7 Wrap these ropes all the way around the front, this time in a row beneath the breast line. Continue wrapping around the back and bring them to the front, beneath the previous wrap.

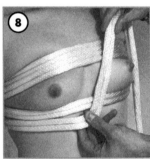

8 At the front, hold the bottom row of ropes with your thumb and make a backward *L* to bring the ropes up over the top rows.

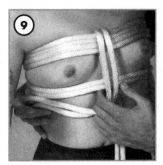

9 Pass these ropes over the top rows and back down behind them. Maintain the L shape at the bottom, while sliding or adjusting all the ropes to remove any slack.

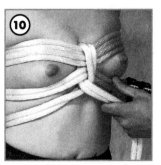

10 Now pull the ropes out front through the corner of the L. As you pull the ropes, the top and bottom rows will pinch together, squeezing the breasts firmly, like pearls.

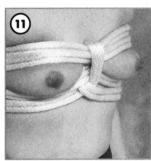

11 Adjust the ropes to keep the rows together and tight around the torso as you bring the ropes to the back.

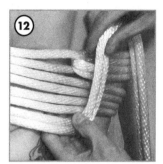

12 In the back, make an L with the bottom ropes, just like you did in the front. Bring the ropes up to the top row at a right angle, up to the bight.

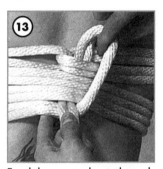

13 Feed the ropes down through the opening in the double-bight. Pull them down behind all the ropes (except the bottom row) and out through the corner of the L row.

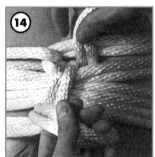

14 Crossing the L to the right, now feed the ropes up behind all the rows and out through the inside of the double-bight at the top (between the first and second rows).

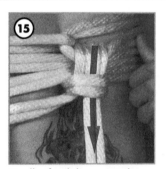

15 Finally, feed the ropes down through the opening made when you crossed the L to the right. Pull the ropes all the way through and tighten this knot securely.

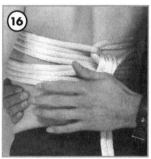

16 Carefully adjust all the rows so they are neatly together without gaps and uniformly tight around the torso. The torso portion is done!

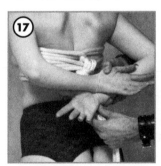

17 To tie the arms, cross both wrists behind the back, atop both the ropes.

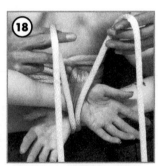

18 Bring the ropes up and over the wrists and down behind them, with each rope on its own side of the center ropes.

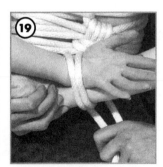

19 Adjust the arms so that the ropes are below the wrist joint and not riding up onto the palms.

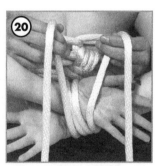

20 Wrap the ropes over the wrists again and down the back, one rope on each side of the center ropes.

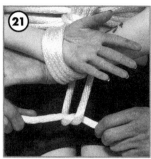

Tie an overhand knot between the wrists and the back.

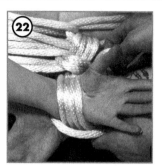

Have your partner bend the wrists to open a space between the wrists and arms. Then bring one rope on each side up and over and down between each wrist and arm.

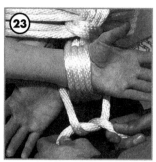

Finish securing the wrists by tying a Square Knot below the wrists.

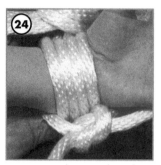

Now everything is done but the fun!

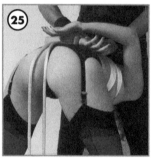

For tying the arms in a more Dominant way, we like to bend our partners and place their heads between our legs and tie the wrists as shown above (but upside down).

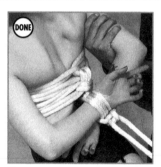

This is a great piece for controlling your partner...

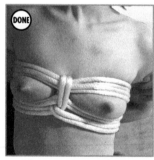

and for stimulating the breasts.

The Pearl Harness always seems to leave quite an impression (on the skin and in the mind).

Basketing Hog-Tie

The Basketing Hog-Tie is unlike the traditional hog-tie in that it fixes tyees' legs to their upper backs, rather than to their wrists. Also, it is dynamic. This dynamic aspect of the Basketing Hog-Tie allows people who tie it to control the amount of intensity their partners experience—with the simple pull of a rope.

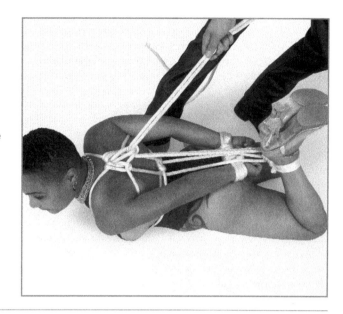

Rope length: One 40 to 50 feet, two 10 to 15 feet
Rope diameter: ³/₈ inch to ⁷/₁₆ inch

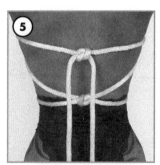

1 Place the middle of the long rope behind your partner's neck, having him or her hold the rope in a triangle at her armpits. Tie a Square Knot at chest level.

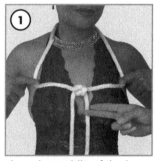

2 Split the dangling ends of rope apart, then pull each respective end under your partner's chest and around to the back.

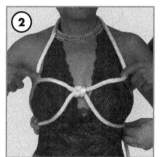

3 Tie the ropes together at the back using another Square Knot.

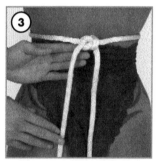

4 Split the dangling ends of rope back to your partner's chest and pass their ends under and through the triangle of rope your partner is holding in place.

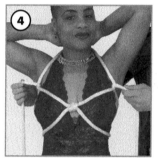

5 Bring the dangling ends of rope back around to your partner's back and tie another Square Knot.

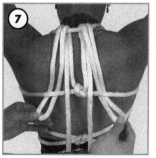

6 Bight the end of each respective rope up and under the loop of rope around the back of your partner's neck.

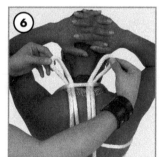

7 Make the bights longer and pull them down and under the strip of rope tied across your partner's shoulder blades.

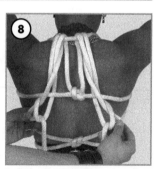

8 Fish each respective dangling end of your rope through the loops of each bight.

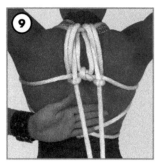

Pull the ropes down...

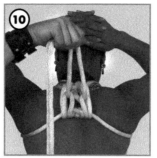

and then pull up again to tighten them.

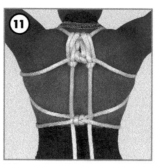

Weave the dangling ends of your rope under the bottom section of the X of rope at the small of your partner's back.

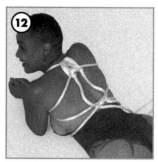

Now have your partner lie belly-down on the floor.

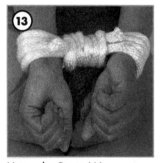

Using the Basic Wrap, use one of the shorter ropes to tie your partner's wrists. Use the other short rope to tie your partner's ankles in another wrap.

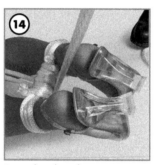

Pass the dangling rope ends of your chest harness under the rolls of the Basic Wrap tied around your partner's ankles.

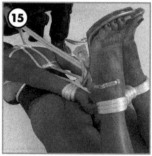

Pull the dangling rope ends back toward your partner's shoulder blades.

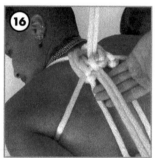

Thread the dangling rope ends under and up through the opening above the Square Knot tied at your partner's shoulder blades.

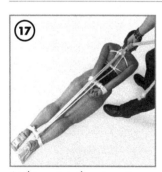

At this point, the piece is essentially complete.

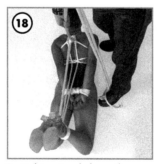

To tighten (and draw the ankles up to the back), pull the rope ends up...

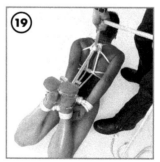

until the desired tension (or basketing) is achieved.

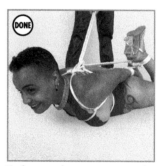

To loosen the tension, simply allow slack for you partner to relax.

Double Coin Knot Bra with Wrist Tie-Back

Chinese merchants once took the design of the Double Coin Knot to represent prosperity. For us, the Double Coin Knot represents an ideal knot for securely harnessing the chest, while maintaining a clean and elegant look. Also, because the Double Coin Knot is flat, the tyee can lie chest-down with little if any discomfort from the knot.

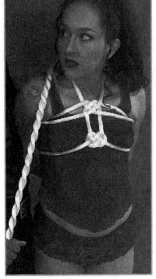
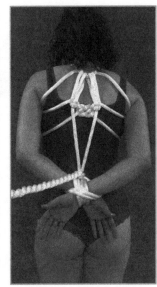

Rope length: 40 to 50 feet
Rope diameter: 3/8 inch to 1/2 inch

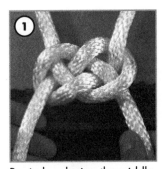

1 Begin by placing the middle of the rope around the back of your partner's neck. At the top of the chest tie a Double Coin Knot.

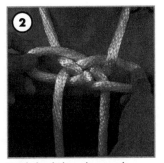

2 With both hands, pinch the left and right loops of the Double Coin Knot and stretch them out until they reach the front of your partner's armpits.

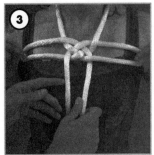

3 Have your partner hold the stretched loops of the Double Coin Knot in place.

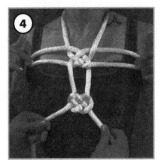

4 Just below the chest, tie a second Double Coin Knot. Make sure the knots are flat.

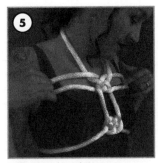

5 Take the dangling ropes below the second Double Coin Knot and split them flat across your partner's chest. Then, move behind your partner with the dangling ropes in hand.

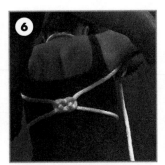

6 On the spine of your partner, tie a Double Coin Knot. Make sure the Double Coin Knot is securely tightened, but flat.

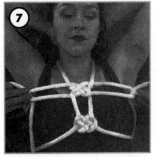

7 Now fish the respective rope ends underneath and then out the stretched loops of the Double Coin Knot your partner's been holding.

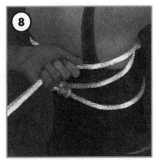

8 Pull the lengths through the loops. Follow up by pulling the rope ends snugly back toward you.

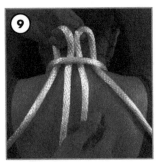

9

With the dangling ropes running down your partner's spine, loop each rope into a bight. Pull the bights up beneath, then over the rope at your partner's neck.

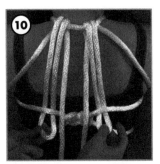

10

Using both hands, pull the two bights down to, then beneath the ropes atop the X formed by the stretched Double Coin Knot along your partner's back.

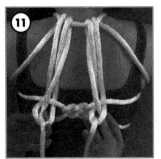

11

With both thumbs and forefingers, fish each dangling rope behind and through its respective bight.

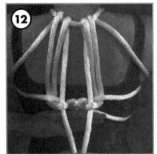

12

Now pull the ends of the dangling ropes completely through the bights.

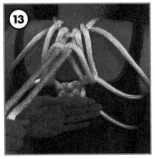

13

Now grip the dangling ropes and pull them up toward the loop at your partner's neck...

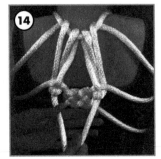

14

and then down again. Repeat the procedure as many times as necessary to eliminate all slack.

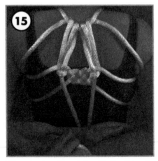

15

Once the Double Coin Knot Bra is complete, bring the arms of your partner back until they are both lying atop the dangling ropes.

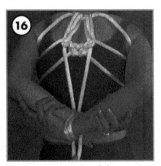

16

Then bring each of the dangling ropes up and over both wrists. Make sure that each rope wraps around its wrist and outside of the vertical ropes down the back.

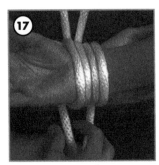

17

Repeat Step 16, but wrap the ropes outside of the ones you previously wrapped.

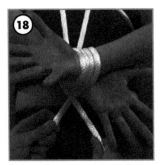

18

Below the wrists, cross the right dangling rope over the left and have your partner fan his or her fingers, palms facing back.

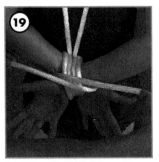

19

Bring each dangling rope back toward you, between your partner's wrists and forearms. Then wrap the ropes past each other and away from you toward your partner's back.

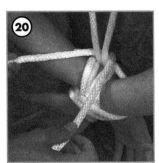

20

Once behind your partner's wrists, cross the right dangling rope over the left, and bring the ropes toward you again.

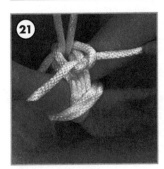

21 Tie an overhand knot securely around the ropes leading up above your partner's wrists.

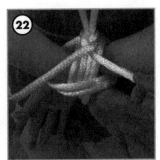

22 To finish the piece, take both ends of the dangling rope, one in each hand, and cross them while rotating them both counterclockwise.

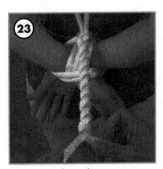

23 Begin cording the rope, twisting each rope clockwise before winding it over the left. (See Cording Rope Ends, page 19.)

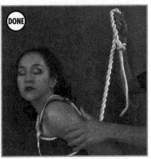

DONE Tie an overhand knot in the ends of the rope to secure them, making the cord into a nice leash to your partner's back.

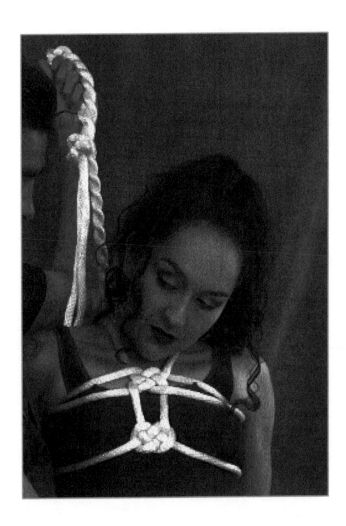

The Quick Bit Gag

In truth, the Quick Bit Gag is merely a clever application of a multiple overhand knot. Also known as a "blood knot" (since it was tied into the ends of cat-o'-nine-tails), the multiple overhand knot makes for a quick, secure knot for a muffling gag! (It's not a bad sight gag, either.)

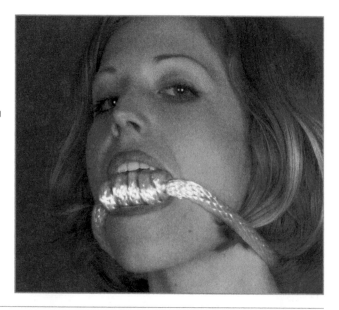

Rope length: 5 to 10 feet
Rope diameter: ³/₈ inch to ⁷/₁₆ inch

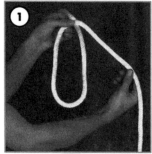

Start by first tying a simple overhand knot—making sure to leave a large hand-sized loop beneath.

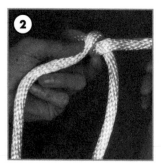

Then repeatedly coil the rope around the top of the loop.

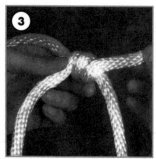

Make sure to wrap each coil snugly...

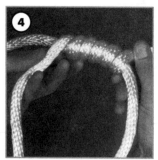

until you've made four to five snug coils around the top of your loop.

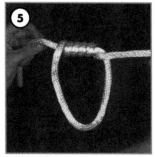

With both loose ends of your rope in hand...

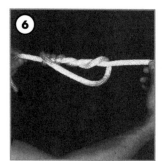

draw the knot up by pulling with one steady smooth pull.

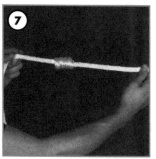

When complete, only the coils are visible between the loose rope ends.

With a willing partner in hand, you're in business!

Bridle

Hold your horses! We Two Knotty Boys believe that unbridled passion isn't nearly as fun as bridled passion. If you ever have a desire to try pony play or effectively control your submissive by the head, this piece can't be beat. You can even tie it once, throw it in your kit bag, and use it as needed, again and again.

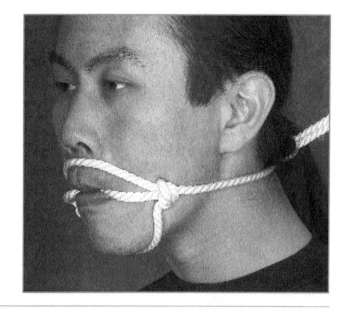

Rope length: 10 to 15 feet
Rope diameter: ¼ inch preferable

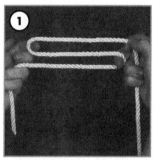

1 At the middle of the rope, make an *S* shape.

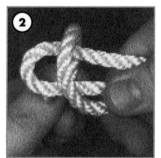

2 Hold one side of the *S* securely while you wrap the lowest rope all the way around all three sections of rope.

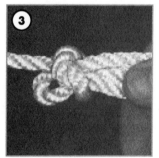

3 Pull the end of the rope (that you just used to wrap) through itself to form an overhand knot that pinches the ropes together tightly.

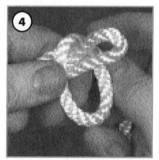

4 Tie the same overhand knot on the other side.

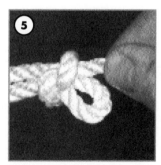

5 Be sure the overhand knots pinch their loops as tightly as possible.

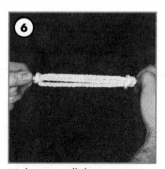

6 Make sure all three ropes are equal length. You knot aficiondos might notice that you have just made what looks kind of like a sheepshank, only this is more secure.

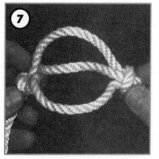

7 Push the sides together to open up the piece.

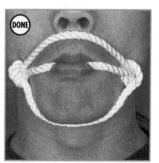

DONE Then have your partner bite on the middle rope while you place the bottom rope under the jaw and the upper rope under the nose.

Rope Cage

The Rope Cage is yet another elegant tie that utilizes the Double Coin Knot in its construction. When completed, the tie comfortably limits a partner's ability to move, while at the same time allowing him or her to be pivoted freely on the feet like a "willow in the wind." Since it consumes a lot of rope, this tie can be a bit cumbersome for beginners. However, with a little practice, tying it will soon be a breeze!

Rope length: 80 to 100 feet
Rope diameter: $3/8$ inch to $7/16$ inch

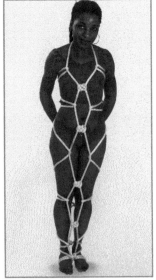
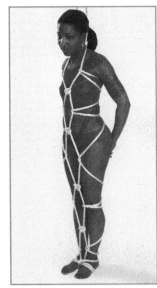

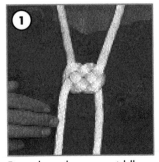

First place the very middle of the rope around the back of your partner's neck. At chest level, tie a Double Coin Knot.

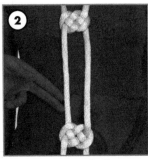

At your partner's belly button, tie another Double Coin Knot.

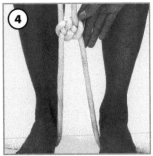

Then, at your partner's knees, tie another...

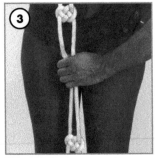

and at his or her lower calves, tie another.

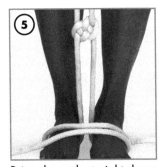

Bring the ends straight down and have your partner stand (feet together) on each rope, bringing each rope off to its side. Now wrap each rope over both feet.

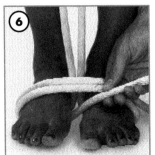

Take the ends of the rope, and split one up behind and one up the front of the wrapped ropes.

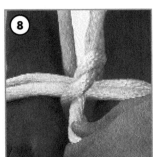

Split the rope ends over the back and the front side of the wrapped ropes.

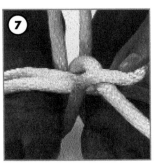

Tie a basic overhand knot to pinch the wraps together.

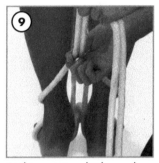

At this point, split the ends of the rope in opposite directions around your partner's ankles until you reach the back.

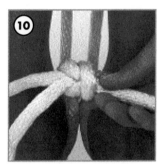

Tie a basic Square Knot behind your partner's ankles.

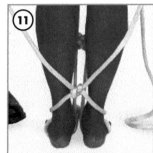

Split both respective rope ends and bring them around toward the front of your partner's lower shins.

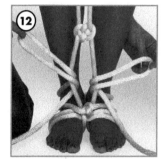

Then weave each rope under each vertical rope on its respective side, pulling it through, above the overhand knot. Pull the ropes apart to make a diamond.

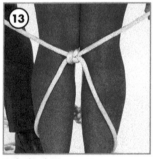

Split both respective ropes, pulling them around the back of your partner's calves. Tie a basic Square Knot behind the knees.

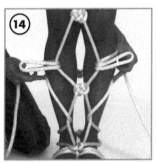

Split both respective ropes around to the front of your partner's upper shins. Pull the ropes apart between the legs, above the Double Coin Knot, to form another diamond.

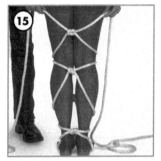

Split both respective ropes around toward the back of your partner's thighs. Tie a basic Square Knot.

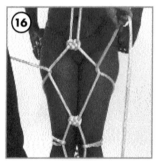

Split both respective ropes around to the front of the thighs. Pull the ropes apart between the thighs and above the Double Coin Knot to form another diamond.

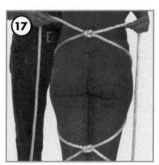

Split both respective ropes around to the small of your partner's back. Tie a basic Square Knot.

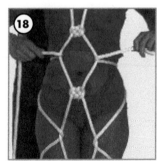

Split both respective ropes around to the front of your partner's waist. Pull the ropes apart between the Double Coin Knots to form another diamond.

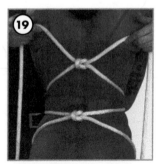

Split both respective ropes around to the middle of your partner's back. Tie a basic Square Knot.

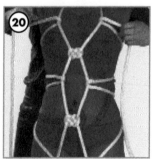

Split both respective ropes around to the front of your partner's chest. Pull the ropes apart above the breast line above the Double Coin Knot.

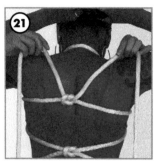

Split both respective ropes around to your partner's shoulder blades. Tie a basic Square Knot. Bring the ropes up to the back of the neck.

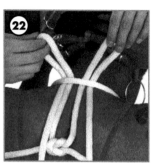

Make a bight in each rope and pull each respective bight up and under the rope that's around the back of the neck.

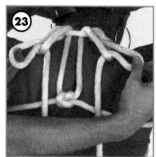

Tie off the piece by pulling each respective loose end all the way through its respective bight.

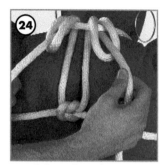

Carefully pull each rope until its respective bight collapses onto it...

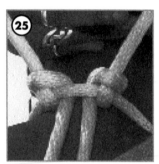

until tight!

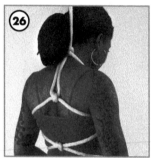

The loose ends can then be tied off to an overhead eyebolt or looped around a ceiling beam, holding the piece tight and your partner upright.

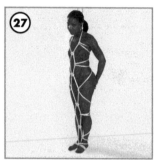

Whether viewed from the front...

or the back, the piece should look clean and well fitting, while still allowing plenty of accessibility.

Sex Bondage

Table Tie-Down

Here is a sexy application of the Basic Wrap for turning a simple coffee table into a not-so-simple conundrum for your partner (or a simply great time for both of you). The same rigging can also be used for dining room tables, desks and most other four-legged furniture.

Rope length: Two 25 to 35 feet, two 10 to 20 feet
Rope diameter: ³/₈ inch to ⁷/₁₆ inch

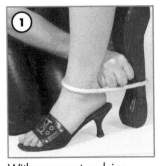

With your partner lying back-down on the table, dangle each leg off the corner. Leave one fist distance between the ankle and the table leg.

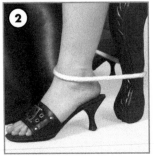

Place the very middle of one of your 10 to 20 foot ropes on the outside, wrapping around the ankle and the table leg.

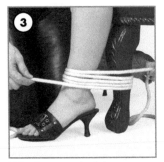

Wind one end of the rope two times around the ankle and table leg, winding above the first rope. Then wind the other end of the rope two times below the first rope.

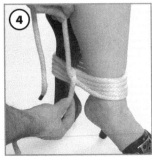

When you have five flat winds of the rope (and the remaining lengths are equal), cross the top and the bottom ropes, like you're wrapping ribbon around a package.

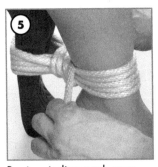

Begin winding each rope vertically (in opposite directions) around the five horizontal windings, toward each rope's respective side.

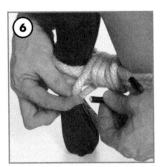

To tie off the wrap, lift the last winding on each side and fish its respective rope end through the opening, from the inside to the outside. Pull the ends to tighten the wrap.

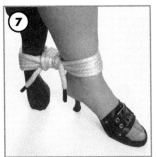

To ensure circulation, push the vertical wraps toward the table leg so there is enough space to fit one finger between the wrap and ankle.

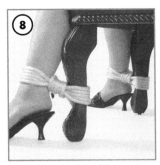

Using your other 10 to 20 foot rope, repeat the wrap on the other ankle.

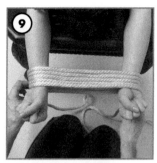

Pull both arms above your partner's head. Using one of your longer lengths of rope, start making a Basic Wrap around the wrists, some distance apart.

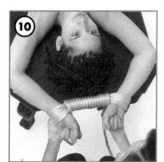

Complete the Basic Wrap. You can start with the wrists as wide apart as you like, depending on the length of your rope and the width of the table.

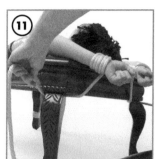

Secure the wrists to the table by wrapping each end of the rope around the table legs, first under and to the inside, then around the outside.

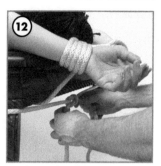

Tie the ends of the rope together using a Square Knot.

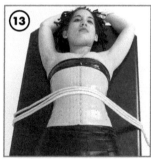

You can further secure your partner to the table by wrapping the ropes several times around the table and the waist. Bring both rope ends to one side of the waist.

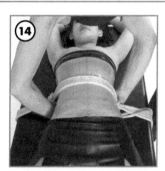

Cross these ropes and wind them horizontally in opposite directions around the vertical wraps, passing under your partner's waist.

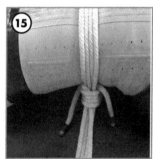

Tie off the wrap at the waist, just as you did with the wrist and ankle wraps.

Now your partner is going nowhere, and bound to enjoy a little coffee break.

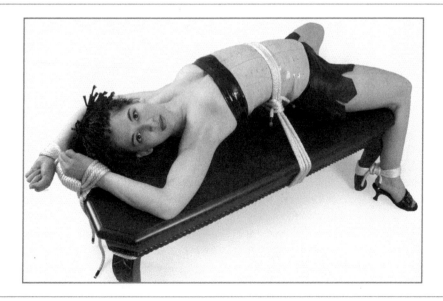

Chair Bondage: Kneeling

Here's a fun way to turn an armchair into a perfect platform for bondage passion. Using a single rope on each side, it incorporates the Shackle tie (shown previously for the wrists) to secure the knee, and then uses rope corsetry to secure the arm and finally a collar. As for what you can do with your partner restrained in this vulnerable kneeling position, we'll leave that up to your imagination.

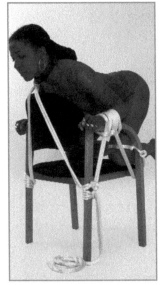
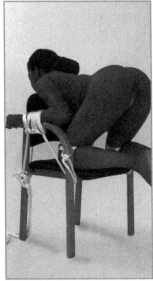

Rope length: 2 ropes, 20 to 30 feet each
Rope diameter: ¼ inch to ½ inch

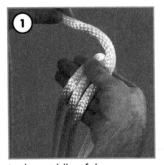

1. In the middle of the rope, form three loops large enough to go around your partner's lower thigh. Holding them together, make a *7* by crossing the right-most rope over all.

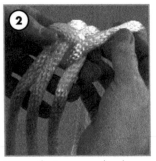

2. Wrap that rope under the left two ropes and bring it out above the third rope (itself). Drop the end away from you to keep it out of the way.

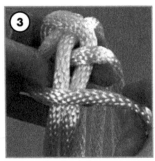

3. Now take the left-most rope and make an *L* by crossing it over the other two.

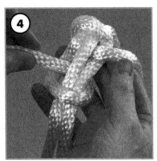

4. Wrap that rope under the right two ropes and bring it out above the first rope (itself). Drop the end toward you.

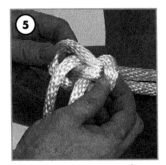

5. With your partner standing, pull the shackle up the leg, to just above the knee. To tighten it, first pull the "ears" of the knot outward to shrink the loops around the leg.

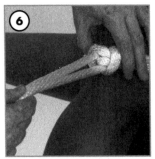

6. Holding the knot against the outside of the knee, pull the ends of the rope to tighten the "ears" back into the knot. Be careful not to tighten it so much that it cuts circulation.

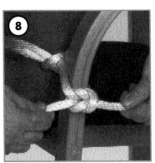

7. Have your partner place that knee near the front edge of the chair and right against the arm post. Take one rope on each side of the post.

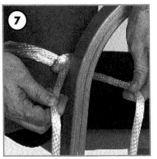

8. Tie a Square Knot on the outside of the post. This should be tight, since it doesn't impact circulation.

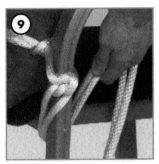

Pull both ropes DOWN the front of the chair, UNDER the inside of the post and then UP behind the post.

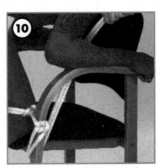

With your partner's arm flat against the armrest, bring the ropes up along the INSIDE of the armrest and around the upper part of the forearm.

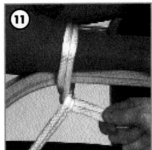

Pass the ropes BEHIND the previous ropes and forward. Do NOT make a knot here.

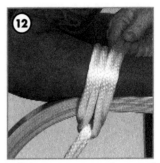

Pull the ropes up and around the outside of the forearm. Keep tension consistent but not uncomfortably tight. Lay the ropes up against the previous wrap.

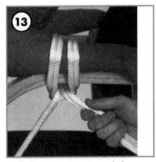

Pull the ropes around the inside of the arm and out through the loop created when they doubled back. Pull the ropes forward and back to the inside again.

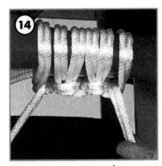

Continue wrapping the arm like this with alternating loops until you reach the wrist.

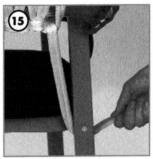

Once through the final loop, pull the ropes DOWN and INSIDE the rear leg post.

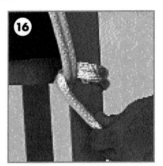

Wrap them around the outside of the post and under the ascending ropes, then around the outside of the post.

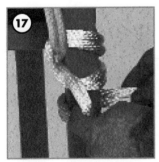

Just like you wrapped the arms, continue winding interlocking loops down the leg of the chair.

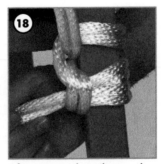

After two or three loops, the ropes will be secure enough to stay, even without a finishing knot.

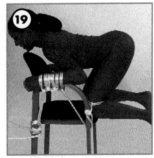

Repeat all the above steps on the other side using a second rope.

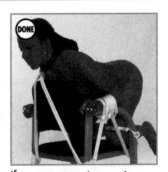

If your partner is wearing a collar with a ring, you can bring one pair of the remaining ropes up through the collar ring and tie off the ends to the opposite leg of the chair.

Seated Chair Tie

A useful application of the Rope Shackle, the Seated Chair Tie is an excellent restraint for interrogation scenes and extended play with a partner who prefers to "sit out" a good time. It's also a great way to restrain a male partner in a seated position for sex. The Dominant partner can straddle or sit upon the partner and maintain total control. Designed for both comfort and restraint, this tie makes the most out of a simple chair with front and rear leg bracing.

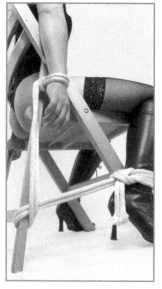
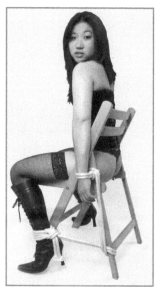

Rope length: Two 20 to 30 feet lengths
Rope diameter: ³/₈ inch to ⁷/₁₆ inch

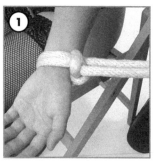

Begin the piece by first tying a Rope Shackle on each of your partner's wrists.

Make sure your partner's shoulders are centered and level with the top of the chair. (Otherwise you may tie him or her into a lopsided position.)

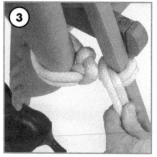

Wrap the loose ends of the Rope Shackle around the rear leg of the chair. First wrap around the outside, then the inside, and finally out over itself and down.

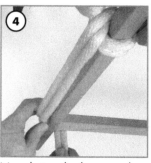

Now bring the loose ends down the length of the back leg until you're beneath the rear leg brace. Wrap the loose rope ends around the inside of the back leg of the chair...

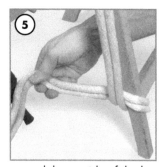

around the outside of the leg and in front of itself.

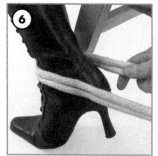

With your partner's legs split and parallel to the front legs of the chair, wrap the loose ends of the rope around the outside and then inside of the ankles.

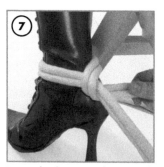

Bring the loose ends around the back of the ankle, then over the ropes and back under and around them.

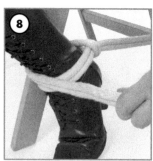

Wrap the ropes back around to the front of the ankle. Then wrap them around to the back of the ankle.

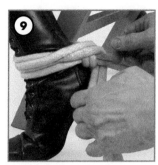 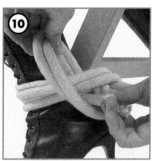 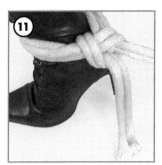 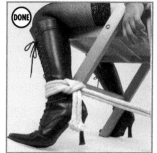

Wrap the loose ends over and under themselves...

then bring the ends through the loop you just created.

Cinch the loose rope ends down tightly to secure.

Repeat these steps on the other side of the chair for your partner's other wrist and ankle. Then your partner will be sitting pretty!

Rope Strap-On

Here's a fun way to make a comfy but rock-solid strap-on harness using rope and your favorite vibrator. This harness enables the woman wearing it to enjoy herself at the same time she's pleasing/impaling her partner. You'll be surprised—it keeps the vibe so secure you could hang a towel on it. Alternatively, you can insert the vibrator tip-down and use this harness as a way to apply hands-free constant and adjustable pleasure to your partner.

Rope length: 15 to 25 feet
Rope diameter: ¹/₈ inch to ⁷/₁₆ inch

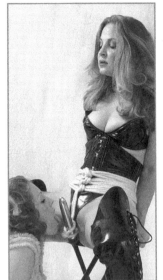
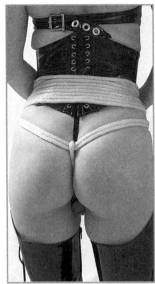

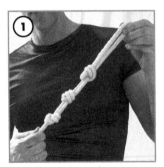

1 Start by making three overhand knots about 6 to 10 inches from the end of a bight in the middle of the rope. Space the knots a little less than the diameter of the vibrator.

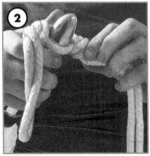

2 Insert the vibrator tip through the first opening between the knots nearest the end of the bight.

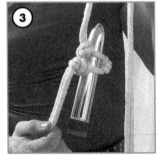

3 Insert the vibrator through the next opening between the knots.

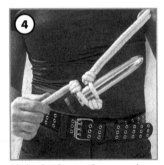

4 Slide the knots down to the hilt of the vibrator. If your knots are close enough together, the vibrator will stay secure.

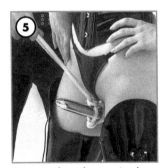

5 Position the vibrator (with the two knots facing up) under the crotch at the desired angle.

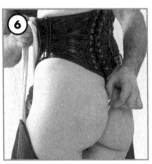

6 Pull the bight up the rear like a thong.

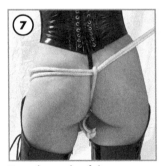

7 Pass the ends of the rope through the bight…

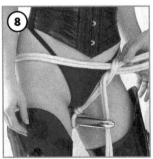

8 and bring the ends around to the front. Pull them under the ropes that went around the other side…

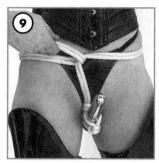

and double back the ropes to make a *T* shape.

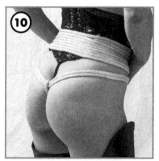

Bring the ropes back around the hips in the opposite direction from which they came.

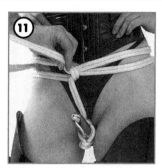

Just as with rope corsetry, thread the ropes down and through the loop created when the ropes doubled back.

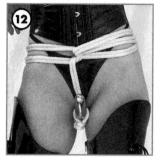

Pull the ropes back around the hips in the opposite direction. Keeping the ropes parallel atop the previous layer, bring them around to the front on the other side.

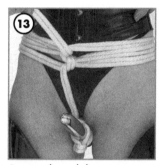

Again, thread the ropes down and through the loop created when the ropes doubled back. Then pull the ropes back around the hips the opposite way.

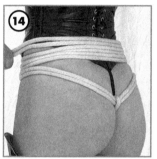

Repeat this doubling back, corsetry technique until you are nearly at the ends of your ropes.

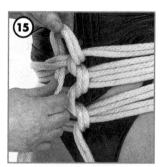

Tie off the corset/harness by doubling back a final time and threading the ends of the ropes under the top layer of ropes...

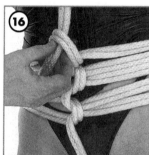

then up through the loop that opened when you doubled back.

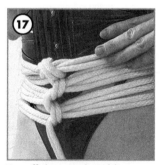

Tie off this overhand knot and tuck the ends behind the front of the corset.

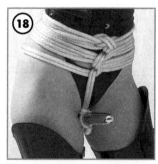

The rope corsetry technique gives your strap-on vibrator considerably more class.

The back of the Strap-On looks like a combination thong and corset. Keep all layers of ropes around the back flat and together.

Then get down to the business at hand!

Suggested Reading

Bannon, Race. *Learning the Ropes.* Los Angeles, California: Daedalus Publishing Company, 1993.

Brame, William and Gloria Brame. *Different Loving: The World of Sexual Dominance and Submission.* New York, New York: Villard, 1996.

Rose, Chanta. *Bondage For Sex.* San Francisco, California: BDSM Press, 2006.

Easton, Dossie. *The Bottoming Book: How to Get Terrible Things Done to You by Wonderful People.* Oakland, California: Greenery Press, 1998.

Easton, Dossie. *The Topping Book: Or, Getting Good at Being Bad.* Oakland, California: Greenery Press, 1998.

Easton, Dossie. *When Someone You Love Is Kinky.* Oakland, California: Greenery Press, 2000.

Harrington, Bridgett and Circle23. *Shibari You Can Use: Japanese Rope Bondage and Erotic Macrame,* Beaverton, Oregon: Mystic Productions, 2006.

Henkin, Bill and Sybil Holiday. *Consensual Sadomasochism.* Los Angeles, California: Daedalus Publishing Company, 1996.

Midori and Craig Morey, Craig. *The Seductive Art of Japanese Bondage.* Oakland, California: Greenery Press, 2001.

Miller, Philip and Molly Devon. *Screw the Roses, Send Me the Thorns: The Romance and Sexual Sorcery of Sadomasochism.* Fairfield, Connecticut: Mystic Rose Books, 1988.

Warren, John. *The Loving Dominant.* Oakland, California: Greenery Press, 2000.

Wiseman, Jay. *Jay Wiseman's Erotic Bondage Handbook.* Oakland, California: Greenery Press, 2000.

Wiseman, Jay. SM 101: *A Realistic Introduction.* Oakland, California: Greenery Press, 1998.

Suggested Viewing

Jay Wiseman Teaches Basic Rope Bondage. Dir. Jay Wiseman, Jay. Jay Wiseman, 2006.

S/M Arts Collection: Featuring The Pain Game & Tie Me Up! Dir. Cleo DuBois. Cleo Dubois, 2005.

Glossary

bight
(noun) (Pronounced BITE.) A *U*-shaped semicircle of rope where the rope does not cross itself. Can also be used to assist in the tying of the knot when rope length would make using the actual end of the rope awkward.

cat-o'-nine-tails
A whip made of nine knotted lines or cords fastened to a handle. So named because the wounds it leaves resemble the scratches of a cat.

cording
Twisting two or more ropes together as you wind them around each other in such a way that their untwisting force keeps them from unwinding.

Dom/Dominant
Someone who ties bondage on a standing person by making the person who is being tied turn around, as opposed to a Top who ties by walking around the person being tied.

dress
(*verb*) To remove slack in the knot and to make sure the knot is tied neatly and correctly so that all parts are where they should be.

fistance
An approximate unit of measurement represented by the distance of your thumb-knuckle to pinky-knuckle when making a fist.

hog-tie
To make helpless by tying a person's four limbs together at the wrists and ankles, usually behind the person's back.

loop
A circle of rope in which the rope crosses itself.

rolling rope
(*verb*) The overlapping of one rope across another rope when wound around a body part or object.

tie
(*noun*) A single rope bondage technique or application, or a piece that is tied.

Top
(*pronoun*) Someone who ties bondage on a standing person by walking around the person who is being tied, as opposed to a Dom (Dominant) who makes the person who is being tied turn around.

two-finger rule
An approximate gauge of space between a tied rope and the body part it encircles. Tying the bondage in a way that maintains enough space to fit one or two fingers between the rope and skin allows consistent blood circulation to flow past the area.

Shibari
The traditional style of Japanese rope bondage that involves tying up the bottom with several pieces of thin rope. Shibari differs from Western bondage in that, instead of just immobilizing or restraining the bottom, the bottom gains pleasure from being under pressure and strain from the ropes squeezing the breasts or genitals.

sinnet
A braid or chain of knots (usually the same kind of knot) that forms a narrow band or cord.

symmetrical
The property of having balanced proportions and corresponding size, shape and relative position of parts on opposite sides of a dividing line.

Weave/Weaving
The process of a rope passing alternately over and under each other rope it crosses.

wind/winding
Coiling the rope (in parallel layers) around a body part, object or another rope.

About the Authors

The Two Knotty Boys, Dan and JD, combine a quarter century of rope bondage experience, including tying models for world-renowned fetish photographers. Rope bondage blossomed naturally from JD's former work as an industrial rigger and Dan's hobby as a climbing instructor. Meeting in 1999, as both tied applicants for a bondage-modeling contest, JD and Dan noticed their similarity in bondage styles and philosophy—and they soon teamed up as the Two Knotty Boys. Ever since, they've been performing live shows, rigging photo shoots and teaching bondage to packed workshops nationwide. Dan's years of performing stand-up comedy and JD's extensive knowledge of human physiology add to their uniquely enjoyable and informative teaching style.

The Two Knotty Boys Dan (left) and JD (right) with photographer Larry Utley (center).

Larry Utley is an artist and photographer based in the San Francisco Bay Area. Trained in traditional photography, he now creates work that is a fusion of traditional methods and digital creation. Larry has returned to the art of photography from a career in advertising and graphic design expressly to satisfy his muse. Working with members of San Francisco's fetish, fantasy, and BDSM communities, he documents the creativity and kinky excesses of people engaged in serious pleasure. Larry Utley is the visual auteur of *Women in Control: Iron Fist, Velvet Glove*, with an introduction by Mistress Miranda, and *Fetish Fashion: Undressing the Corset*, with an introduction by Autumn Carey Adamme of Dark Garden Corsetry, both published by Green Candy Press.